LONDON VILLAGES

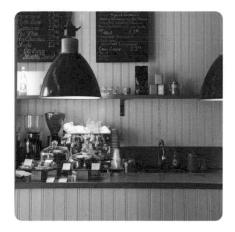

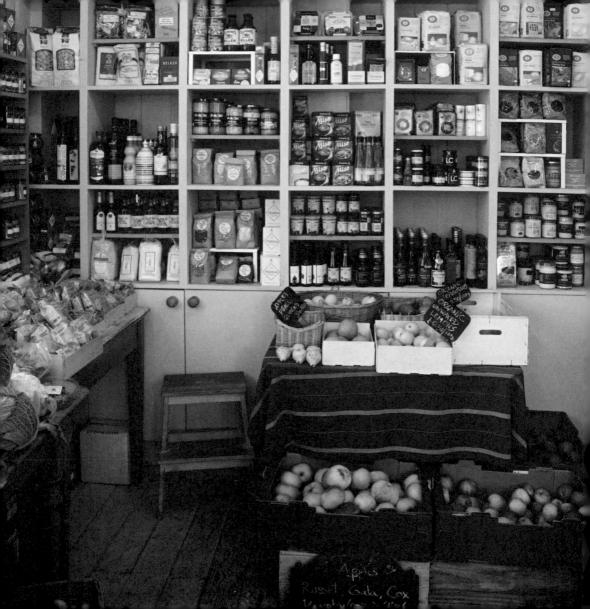

LONDON VILLAGES

ZENA ALKAYAT

WITH

PHOTOGRAPHS BY KIM LIGHTBODY & ILLUSTRATED MAPS BY JENNY SEDDON

London Villages 1. 13

CONTENTS

INTRODUCTION · 6

Central • 8

MARYLEBONE VILLAGE • 2 SHEPHERD MARKET • 3 CONNAUGHT VILLAGE •
 EAST BLOOMSBURY • 5 EXMOUTH MARKET • 6 BERMONDSEY STREET •
 IOWER BELGRAVIA

North • 50

8 PRIMROSE HILL • 9 CROUCH END • 10 HIGHGATE VILLAGE •
 10 CAMDEN PASSAGE • 10 STOKE NEWINGTON CHURCH STREET •
 13 HAMPSTEAD VILLAGE

South • 84

Image: Bellenden Road • Image: Bellenden Road • Image: Bellenden Road • Image: Bellenden Village
 Image: Bellenden Villag

East • 120

20 WHITECROSS VILLAGE • 20 COLUMBIA ROAD • 20 BROADWAY MARKET • 20 VICTORIA PARK VILLAGE • 26 SHOREDITCH VILLAGE

West • 150

23 QUEEN'S PARK • 26 TURNHAM GREEN • 27 BARNES VILLAGE •
 23 LITTLE VENICE • 29 GOLBORNE ROAD • 30 CLARENDON CROSS

INDEX • 186

Introduction

London is often described as a series of 'villages'. This rather romantic image is partly down to history (the capital grew by consuming the constellation of communities that surrounded it), and partly because Londoners have long found ways to make this vast, intense city feel a more intimate and manageable place to live.

In reality, London firmly remains one sprawling metropolis, and this book doesn't mean to pretend otherwise. Instead, it hopes to introduce visitors and locals to enclaves within the city that have a distinct character, sparky community spirit and keen sense of localism. These may be ancient villages (Hampstead, for example, was in the Domesday Book), or more simply a picturesque spot with typical village-like features – a farmers' market, say, or a pretty central green. It also homes in on streets and locations that have recently developed into contemporary urban 'villages' by virtue of a thriving medley of independent businesses, from butchers and bakers to cafés and boutiques.

There's space here for just thirty of these destinations: a geographically diverse mix of iconic London villages and little known neighbourhoods. By celebrating the essence of each and revealing local highlights, this book hopes to inspire both Londoners and tourists to take an alternative approach to exploring this incredible city.

7

Central

MARYLEBONE VILLAGE • 10 SHEPHERD MARKET • 16 CONNAUGHT VILLAGE • 22 EAST BLOOMSBURY • 28 EXMOUTH MARKET • 32 BERMONDSEY STREET • 38 LOWER BELGRAVIA • 44

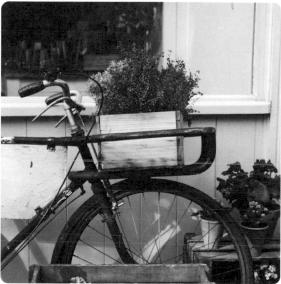

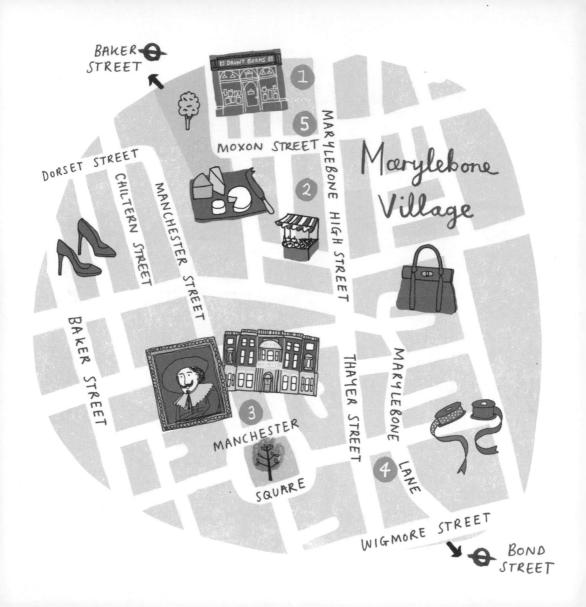

Marylebone Village

Marylebone has always been a well-to-do area, but the 1990s saw it become something of a fashionable destination. Smart boutiques began to open along its central spine, Marylebone High Street, and several upmarket restaurants soon followed suit. Today, the road is crammed with chic fashion labels (such as Maje and Joseph), aspirational homeware stores (The Conran Shop and Designers

Guild), appealing charity shops and excellent pubs and cafés. It's rightly regarded as a more interesting shopping alternative to the more mainstream Oxford Street to the south, and though the invariably wealthy residents see it as their village, it has none of the stiffness of London's more po-faced moneyed areas. This lack of pretension is in part to do with its West End location, which ensures stray tourists and Londoners from further afield make as much use of it as the locals. Those who venture beyond the busy main high street will also find more specialist businesses quietly thriving. Chiltern Street, for example, hides a run of bridal boutiques and woodwind instrument maker Howarth, as well as Cadenhead's Whisky Shop and Tasting Room. On Moxon Street, let your nose lead you to La Fromagerie checse shop, while Marylebone Lane is home

to ribbon specialist VV Rouleaux.

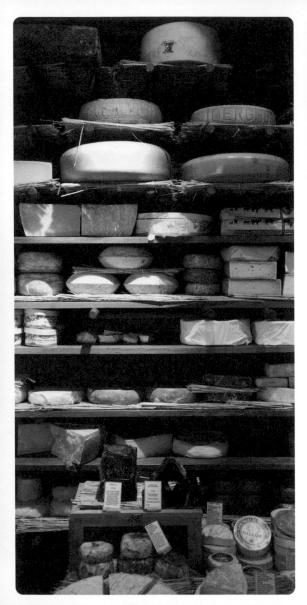

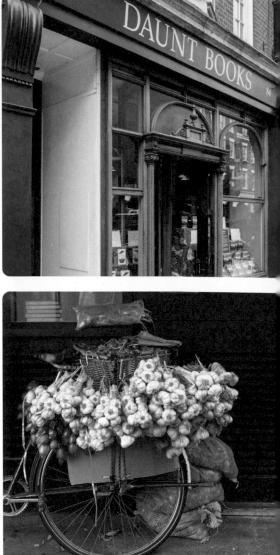

MARYLEBONE VILLAGE

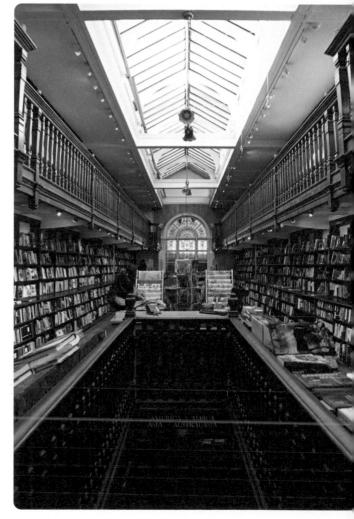

DAUNT BOOKS

83 Marylebone High St, W1U 4QW 7224 2295 www.dauntbooks.co.uk 9am-7.30pm Mon-Sat; 11am-6pm Sun One of London's most prized bookshops, Daunt is loved as much for its Edwardian charm as for its superbly curated fiction, non-fiction and children's book collections. True to its origins as a travel bookshop, it continues to arrange guides and literature by country in a grand backroom and along its oak mezzanine.

MARYLEBONE VILLAGE

2 MARYLEBONE FARMERS' MARKET

Aybrook St, W1U 4DF www.lfm.org.uk 10am-2pm Sun

Despite being one of London's largest farmers' markets, this weekly event, held in a car park behind the high street, is easy to miss. Locals tend to keep it a secret, but follow the ladies wielding wicker baskets and they'll lead you to some 40 stalls selling farm produce, artisan preserves, hot food and wines.

THE WALLACE COLLECTION

Hertford House, Manchester Square, W1U 3BN T7563 9500 www.wallacecollection.org 10am-5pm Mon-Sun This exceptional collection of art, decorative items, furniture and firearms amassed between 1760 and 1880 is displayed in the opulent rooms of the seventeenth-century Hertford House. A visit to the free museum should be coupled with a meal at its elegant courtyard restaurant.

PAUL ROTHE & SON 35 Marylebone Lane, W1U 2NN 7935 6783

8am-6pm Mon-Fri; 11am-5pm Sat Rows of jams and condiments line the windows and walls of this family-run café, which started life as a German deli in 1900. Pop in to browse the shelves, or settle on bolted-down chairs and tables for tea, sandwiches and a bit of banter with Paul Rothe, grandson of the original founder.

LA FROMAGERIE

2–6 Moxon St, W1U 4EW 7935 0341

www.lafromagerie.co.uk 9am-7pm Mon-Sat 10am-6pm Sun Queen of cheese, Patricia Michelson, founded La Fromagerie in 1991 and has three heavenly cheeserooms and cafés in London (the others are in Highbury and Bloomsbury, see p28). As well as incredible cheeseboards, fondue and sandwiches for lunch, the store hosts regular supper nights.

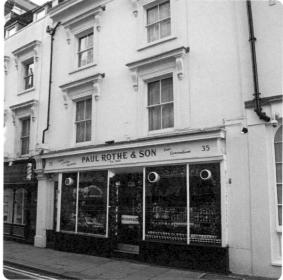

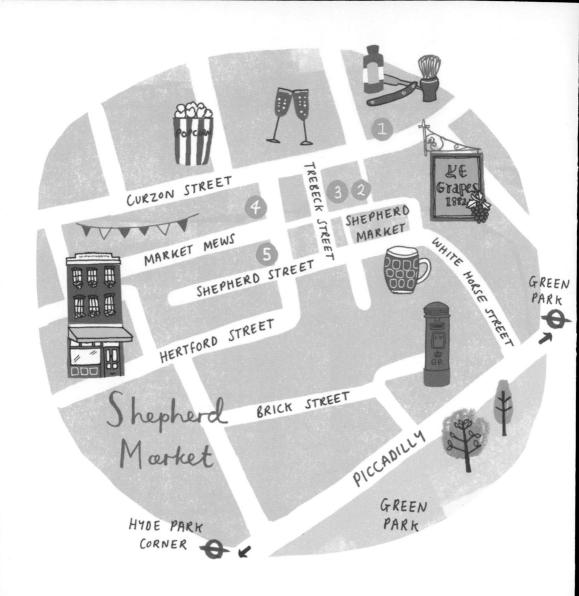

Shepherd Market

Laid out by architect Edward Shepherd in 1735, the secluded streets of Mayfair's Shepherd Market have been privy to some salacious goings-on over the centuries, and a slightly seedy atmosphere still lingers in its narrow network of passageways. The village's historic associations with prostitution, however, are muted by its central location (penned in by the well-heeled Curzon Street and boisterous Piccadilly) and its attractive chocolate-box facade. Behind the picturesque shopfronts lie an array of chichi boutiques, and longstanding services include a cobbler, pharmacy and builders' merchant. The village's main appeal, though, is drinking and dining. High-end restaurants spill alfresco into the alleyways, and a number of popular pubs and bars (including members' club 5 Hertford Street) give Shepherd Market a lively personality come evening. The raucous mood gently recalls the annual twoweek-long May Fair, when crowds would descend on the site for a spot of revelry, gambling and drinking. The event was deemed an affront to public decency and banned in the early eighteenth century, and the area has continued in its attempts to cultivate a refined image ever since.

17

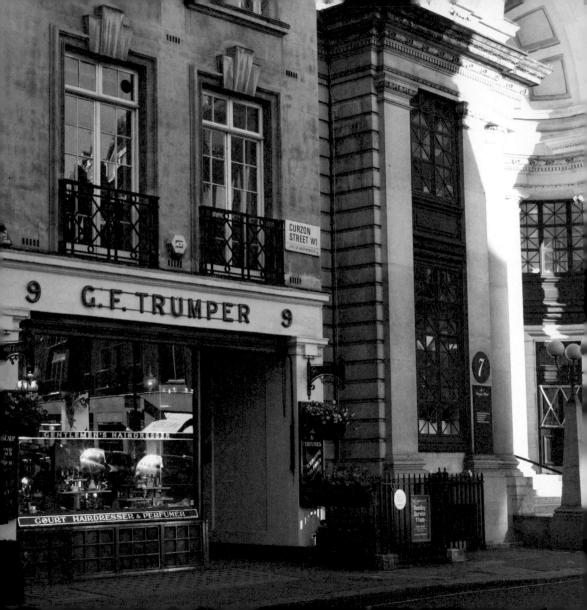

SHEPHERD MARKET

GEO. F. TRUMPER
 9 Curzon St, W1J 5HQ
 7499 1850
 www.trumpers.com
 9am-5.30pm Mon-Fri;
 9am-5pm Sat
 Groomed gents have been enjoying a little primp and preen at this elegant barbershop since 1875, and its dark mahogany interior, private cubicles and traditional wet shave service have barely changed over the decades.

KITTY FISHER'S
 Shepherd Market, W1J 7QF
 3302 1661
 www.kittyfishers.com
 Noon-9.30pm Mon-Sat
 Small but confident, this restaurant is ideal for an intimate dinner and good times. It's where you might peer at someone you fancy over a cocktail and a dish of confit rabbit leg, and it's a place that's bold enough to honour eighteenth-century courtesan Catherine Fischer (who is said to have lived locally) with her name over the door.

LE BOUDIN BLANC

5 Trebeck St, W1J 7LT 7499 3292 Www.boudinblanc.co.uk 5.30pm-10.30pm Tue; noon-3pm & 5.30pm-10.30pm Wed-Fri; 4pm-10.30pm Sat Classic French cuisine, a connoisseur's wine list and rowdy regulars mean this Gallic favourite is always abuzz. Try for a seat outside in fine weather: you'll feel like you're lunching in a Parisian courtyard.

CURZON MAYFAIR 38 Curzon St, W1J 7TY 🕿 0330 500 1331 www.curzon.com

First opened in 1934 (though demolished and rebuilt in the 1960s), the Curzon Mayfair is a long-serving bastion of foreign and arthouse film, and was one of the first cinemas in the UK to import international movies.

S THE CHESTERFIELD ARMS 50 Hertford St, W1J 7SS ☎ 7499 3017 www.thechesterfieldarms.com Noon-11pm Mon-Sat; noon-10.30pm Sun While this village is known for its Victorian boozers (Ye Grapes at 16 Shepherd Market is a favourite), The Chesterfield Arms predates them by some way. Its doors opened in 1737, just as architect Edward Shepherd was initially developing the area.

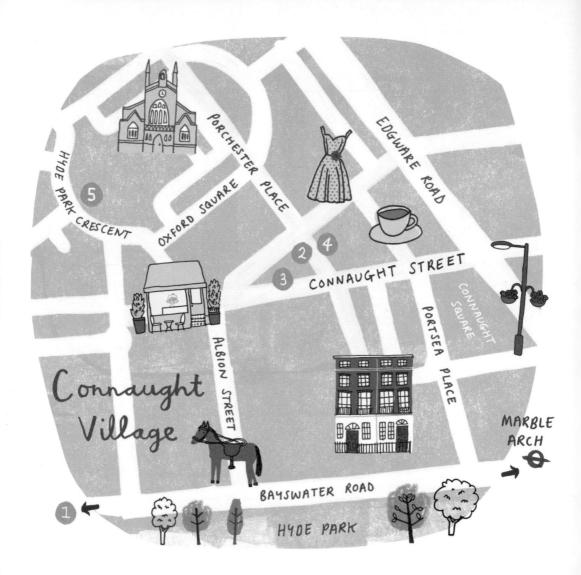

Connaught Village

Edgware Road, with its Middle Eastern community and horn-blaring traffic, tends to do a good job of keeping the sleepy Connaught Village under wraps.

Make your way in via the south end of Edgware Road: you'll know you're close when you spy the grand stucco houses of the area's affluent residents on Connaught Square. Like other parts of this Paddington locale, the square follows the formal designs of English architect Samuel Pepys Cockerell who was initially involved in giving the area (then known as Tyburnia) a facelift in the early nineteenth century. It was a time of ambitious and costly rejuvenation that went some way toward eclipsing Tyburnia's more macabre history as the site

of Tyburn Tree – an infamous gallows which saw plenty of use between 1196 and 1783. A model of the scaffold can be seen in the crypt at Tyburn Convent, a beautiful central London monastery whose Benedictine nuns have kept relics of

the Catholic martyrs that were hanged nearby. The convent's address is 8–9 Hyde Park Place, though its entrance is actually on Bayswater Road overlooking the 350-acre royal Hyde Park.

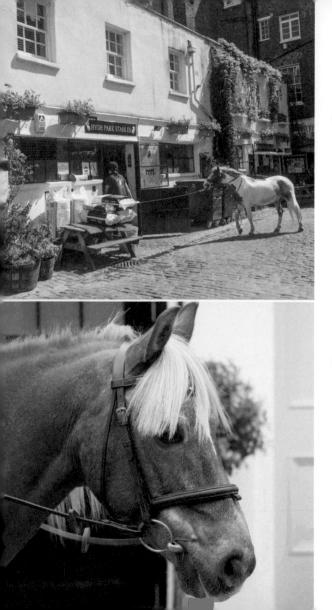

HYDE PARK STABLES 63 Bathurst Mews, W2 2SB 7723 2813 www.hydeparkstables.com First ride 9am, last ride 3pm Mon-Sun Given that most original mews in London have been transformed into homes for the wealthy, it's a charming novelty to see horses still trotting out of their central London stables en route to Hyde Park. Sign up for lessons or private rides with an instructor and you can canter into the park too, all the way up Rotten Row to the Serpentine lake.

MUD AUSTRALIA 11 Porchester Place, W2 2BU 7706 4903

10am-6pm Mon-Fri; 10am-5pm Sat Plates, nest bowls, platters, jugs and more line the shelves in a kaleidoscope of sugary hues in this contemporary ceramics store. All of the simple, hand-pottered tableware (made in Sydney using top-notch Limoges porcelain from France) comes in a handful of pastel colours that look as pretty (and irresistible) as sweets.

CONNAUGHT VILLAGE

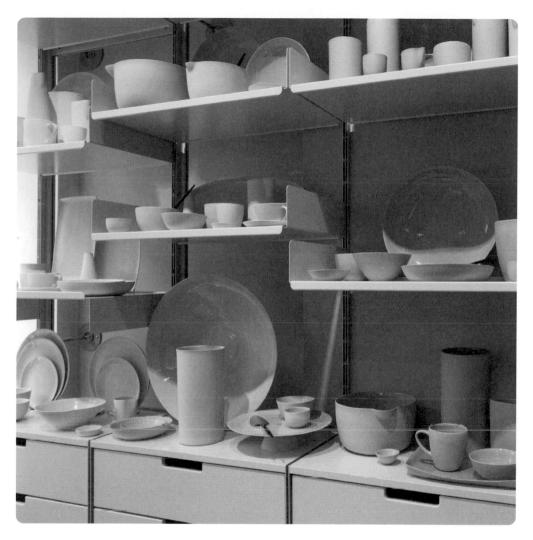

LYON & TURNBULL 22 Connaught St, W2 2AF 7930 9115 Www.lyonandturnbull.com 10.30am-5pm Mon-Fri, by appointment A small outpost of the historic auction house based in Edinburgh. While you won't get the theatre of a full antiques auction, it's worth keeping an eye on its diary for exhibitions and events, as well as the opportunity to view fine art and jewellery ahead of online auctions.

DE ROEMER 14 Porchester Place, W2 2BS 3463 1970 www.deroemer.com 10.30am-6.30pm Mon-Sat

You'll need a sturdy credit limit if you fancy going wild in the aisles of this contemporary cashmere store. But Tamsin De Roemer's line of easy-to-wear jumpers, T-shirts and dresses are a tempting investment, as are the designer's butter-soft leather bags and fashionable collection of fine jewellery.

ST JOHN'S HYDE PARK Hyde Park Crescent, W2 2QD

T262 1732
 www.stjohns-hydepark.com
 This central London church attracts an enthusiastic
 congregation on Sunday mornings, particularly so on
 Horseman's Sunday. This annual September event sees the
 vicar mount a horse, invite churchgoers to do the same,
 and celebrate equestrianism in the city by blessing the
 animals and leading a family-friendly cavalcade and fair.
 The spectacle harks back to 1968 when riders took to their
 steeds to protest against the closure of the area's stables.

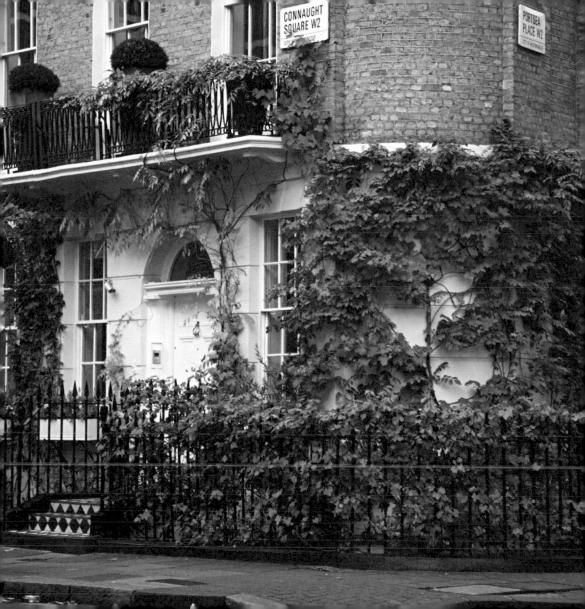

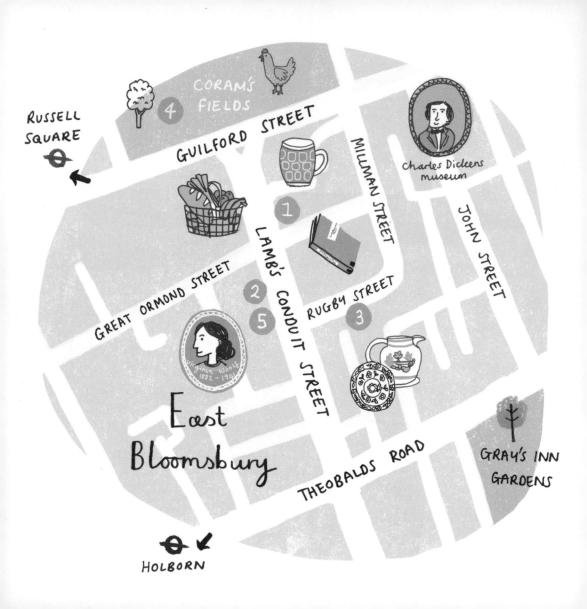

East Bloomsbury

Lamb's Conduit Street has been the backbone of this mini-neighbourhood since the early 1800s when many of the street's houses were taken over by shopkeepers responding to a local demand for retail. Today it remains pleasantly removed from the main tourist trail that swings past the British Museum, and provides another excuse to visit an area primarily associated with the Bloomsbury Group. This artsy, intellectual set – including John Maynard Keynes and Virginia Woolf – haven't been Bloomsbury's only residents of distinction: Charles Dickens lived at 48 Doughty Street (now the Charles Dickens Museum) and Charles Darwin resided in Gower Street. Sylvia Plath and Ted Hughes were said to enjoy a drink at The Lamb, and the pub (at the top of Lamb's Conduit Street) is a good place

to take a break while exploring the road's flurry of cool boutiques. The surrounding streets are equally worth rambling around, offering up coffee

shops such as The Espresso Room (31–35 Great Ormond Street), a huddle of gift shops on Rugby Street and secret patches of green nestled among the buildings.

Make particular note of Gray's Inn Gardens to the south,

which was laid out by Sir Francis Bacon in 1606.

29

THE PEOPLE'S SUPERMARKET 72–76 Lamb's Conduit St, WC1N 3LP 7430 1827

www.thepeoplessupermarket.org 8am-10pm Mon-Sat; 10am-9pm Sun Run 'for the people, by the people', this supermarket is a cooperative venture which asks members to donate £25 a year and four hours of work a month in return for 20 per cent off their groceries. As well as stocking produce by local farmers and supporting the local community through jobs, the store runs the People's Kitchen – a hot food station serving low-priced lunches.

POLK

49 and 53 Lamb's Conduit St, WC1N 3NG 28616 4191

www.folkclothing.com

10.30am-6pm Mon-Fri; 10am-6pm Sat; noon-5pm Sun Folk's menswear and womenswear stores are nearly neighbours, and both are filled the sort of chic, understated, detailorientated apparel that costs a little more than clothes on the high street, but should last you an awful lot longer.

3 PENTREATH & HALL

17 Rugby St, WC1N 3QT 7430 2526 ... www.pentreath-hall.com Noon-5pm Tue-Fri

Interior designer Ben Pentreath and designer and artist Bridie Hall are the duo behind this diminutive shop, and they have a wonderful knack for choosing covetable and unusual kitchenware, stationery and homeware. An ideal place to pick up unique presents.

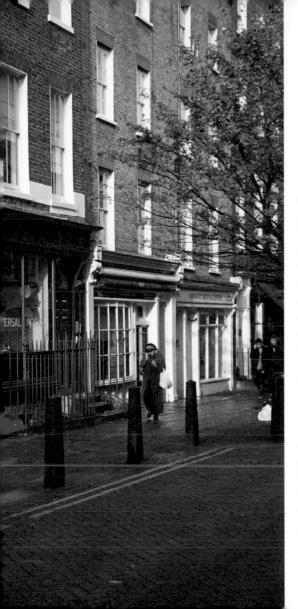

CORAM'S FIELDS 93 Guilford St, WC1N 1DN 7837 6138 Www.coramsfields.org 9am-dusk Mon-Sun

This park is unusually open solely to children and young people – adults can only enter if accompanied by someone under sixteen. There's a small animal enclosure, various playgrounds designed for different age groups and a youth centre which organises a roster of events.

S NOBLE ROT

51 Lamb's Conduit St, WC1N 3NB 7242 8963 Www.noblerot.co.uk Noon-2.30pm & 5pm-9.30pm Mon-Sat Get lost in a wonderful by-the-glass list covering every wallet size, taste and fancy in this wine bar and French-influenced restaurant (set up by the same team behind lauded wine mag *Noble Rot*). There are a few walk-in tables if you fancy just a drink and a snack, but it's worth lingering for the indulgent dishes on a pleasingly short food menu.

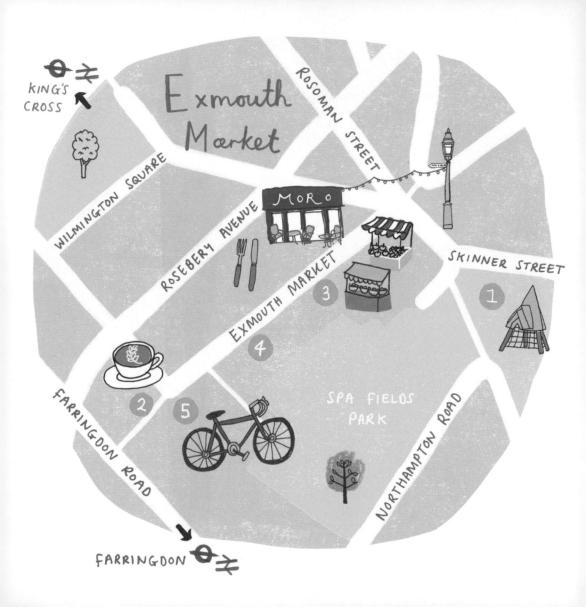

Exmouth Market

Exmouth Market – so named during its turn-of-the-twentieth-century role as a bustling market street – suffered crippling decline in the 1970s. Despite efforts to revive its fortunes, it didn't begin to recover its community character until the late 1990s. Chefs Sam and Sam Clark arguably fuelled the change when they opened the acclaimed southern Mediterranean restaurant Moro in 1997, triggering the arrival of a clutch of equally good eateries. Amble up the short, pedestrianised lane on a weekday and you'll spy smart restaurants together with mobile, global food vendors feeding the lunchtime crowds.

A medley of gift shops, bookstores and services offer further reasons to visit. At the top of the road, Spa Fields furnishes the area with green space and a grim but fascinating story. In the 1780s, the park was known as the Bone House & Graveyard – a site designated to accommodate 3,000 burials. To the horror of local residents, graveyard manager Mr Bird managed to make room for some 80,000 interments by nightly exhuming and burning bodies. Happily, the landscaped gardens are now an attractive place to catch some rays.

3 CORNERS ADVENTURE PLAYGROUND

Northampton Rd, EC1R 0HU 27833 0020 www.awesomeadventureplay.org During term time: 3.30pm-6.30pm Tue-Fri; 11.30am-4pm Sat. During school holidays: 10.30am-5.30pm Mon-Fri

One of the most ambitious and creative park projects in London, 3 Corners Adventure Playground has given children aged six to thirteen a fantastical place to play. Adults are invited to drop off their kids and leave them to enjoy the fully supervised (and free) network of bridges, tunnels, spiral slides, climbing walls and fireman poles.

2 CARAVAN

11–13 Exmouth Market, EC1R 4QD 27833 8115

www.caravanrestaurants.co.uk 8am-11pm Mon-Thu; 8am-midnight Fri; 9am-midnight Sat; 9am-9pm Sun A laidback, good-looking, something-foreveryone dining room. It opens early to serve drip-brewed coffee (roasted in-house), a breakfast menu and a brunch at weekends. Lunch and dinner dishes could be globally inspired small plates, or a large plate that's equally international, from tandoori Welsh lamb to roasted Norwegian cod with cockles.

THE FAMILY BUSINESS TATTOO PARLOUR

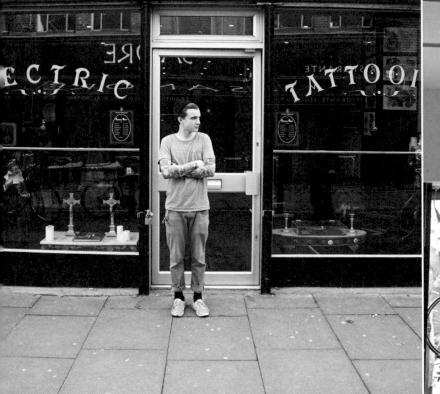

THE FAMILY BUSINESS 58 Exmouth Market, EC1R 4QE 27278 9526

Www.thefamilybusinesstattoo.com By appointment noon-7pm Mon-Sun The roster of tattoo artists at this impressive studio is enormous – and each one is as original, creative and talented as the next. One of the best and most forward-thinking parlours in London.

EXMOUTH FOOD MARKET
Exmouth Market, EC1R 4QL
 www.exmouth.london
Noon-3pm Mon-Fri
Exmouth Market is one of London's
destination streets for cheap eats and quick
bites with permanent pitstop restaurants
including Pizza Pilgrims and Bun Cha. For even
more choice, pitch up during a weekday lunch
and have your pick of street food, from bento
boxes to burritos.

EAST CENTRAL CYCLES 18 Exmouth Market, EC1R 4QE 7837 0651

www.eastcentralcycles.co.uk 9am-5pm Mon-Fri; 11am-4pm Sat Whether you're after an off-the-peg bicycle with a basket or a custom-made road racer, the helpful crew at East Central Cycles are happy to oblige. The store's bike specialists also tackle repair jobs.

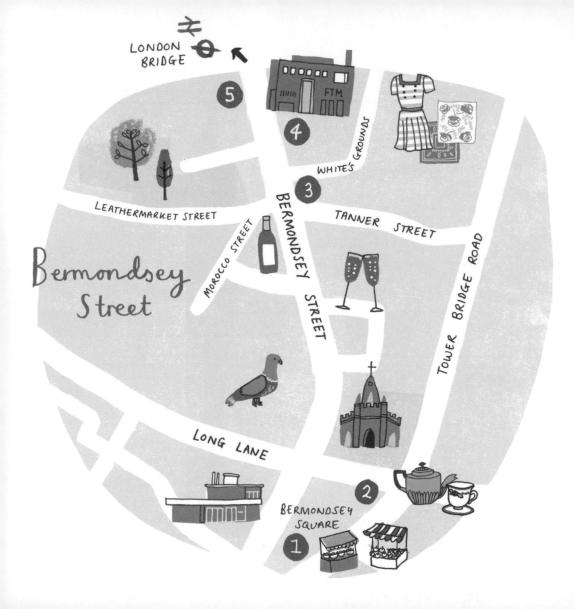

Bermondsey Street

Despite its proximity to Borough Market and the visitor attractions of London Bridge, Bermondsey Street has remained fiercely independent and defiantly local. The peaceful, partly cobbled road rarely shows any sign of tourist overspill, though the presence of iconic contemporary art gallery White Cube goes some way toward encouraging newcomers to the area. Once there, visitors are thrilled with their find: Bermondsey Street proffers an assortment of gift shops and a miscellany of pubs and restaurants. Good gastropubs include The Garrison and The Woolpack, while stellar Spanish chef José Pizarro has two outposts here: tapas bar José and the more roomy restaurant Pizarro (pictured overleaf). It's these sorts of establishments (rather than any central green) that give the long street its current village-like character, though its narrow-fronted shops are hardly new. Bermondsey Street began life as a medieval path for pilgrims travelling to the now long-gone Bermondsey Abbey, and its status as a major thoroughfare was fortified in the nineteenth century when tanneries and workers moved in to support a booming local leather industry.

NI WHITE WINE CHE M ALA SEVILLANA PORK CHEEKS), CHILLI GARLIC IS STEW, MORCIL D FUMPKIN, CHEES AL VINO LIVERS, FIN

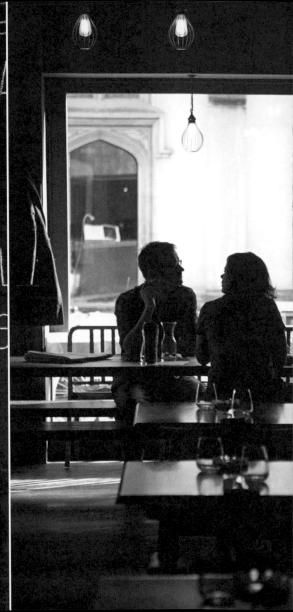

BERMONDSEY STREET

BERMONDSEY SQUARE ANTIQUES MARKET

Bermondsey Square, SE1 3UN www.bermondseysquare.net 6am-2pm Fri

Established in 1950, this local market continues to attract serious antiques traders dealing in china, silverware and glass, alongside stallholders hawking more general secondhand clothes and jewellery. It may not be what it once was, but it still has a great atmosphere.

KINO BERMONDSEY 10 Bermondsey Square, SE1 3UN 7357 6845

www.kinodigital.co.uk

Aiming to suit every taste in the community, this cinema mixes independent and arthouse movies with new releases and kids' films, as well as live screenings of theatre and dance from the National Theatre and the Royal Opera House. Its in-house café-bar and south-facing terrace make it especially popular during summer.

BERMONDSEY STREET

CASSE-CROÛTE 109 Bermondsey St, SE1 3XB 7407 2140
 www.cassecroute.co.uk Noon-11pm Mon-Sat; noon-5pm Sun After a few glasses of Pinot Gris you truly believe you've been transported to a bistro in a Parisian suburb, such is the authentic and heady charm of this tiny, very popular restaurant. Expect red checked tablecloths, a blackboard menu of homely classics (listed entirely in French), rickety chairs, family-like staff and excellent, excellent wine.

FASHION AND TEXTILE MUSEUM

83 Bermondsey St, SE1 3XF ☎ 7407 8664 🖾 www.ftmlondon.org 11am-6pm Tue-Sat

It's impossible to miss this striking electric orange and pink museum. Founded by colourand print-loving designer Zandra Rhodes in 2003, it curates temporary exhibitions, encompasses a café and shop, and runs industry-relevant courses with Newham College.

BERMONDSEY STREET

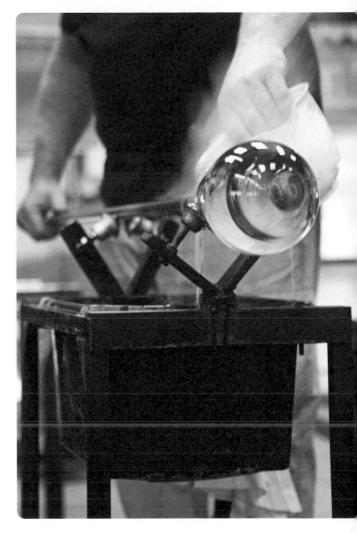

LONDON GLASSBLOWING 62–66 Bermondsey St, SE1 3UD 7403 2800 www.londonglassblowing.co.uk 10am-6pm Mon-Sat Peter Layton opened this space in

1976, creating a shop-gallery at the front and installing a hot glass studio out back where you can pull up a chair and watch glassblowers at work. Layton's own glassware is on display in the showroom, along with functional and decorative pieces by other contemporary makers.

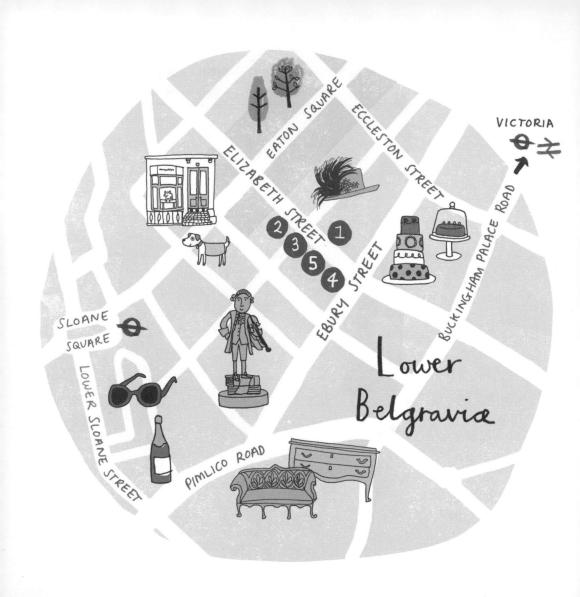

Lower Belgravia

The genteel Ebury Street runs from Victoria station in the north right down to Pimlico Road in the south – crossing it almost directly in the centre is Elizabeth Street. Here, a small cluster of classy boutiques and their coloured awnings give the sleepy area a jolt of life. The shops are subtly geared toward the wealthy and you'll spy well-to-do women hiding behind their sunglasses as they nip into luxury fragrance store Jo Loves (42 Elizabeth Street) and dapper gents plumping

for a fine bottle of Bordeaux in wine merchants Jeroboams (50 Elizabeth Street). For all the pomp, however, there's a real community spirit in this hidden neighbourhood and the local pubs and cafés are filled with friendly residents. To get the most out of a visit, arrive via Sloane Square, then head down Lower Sloane Street and take time to explore the dozens of antique and interiors shops along Pimlico Road. En route, make a stop at Orange Square, where a bronze statue commemorating the brief residence of Mozart is erected and a Saturday

> farmers' market caters for locals. From here, Elizabeth Street is just a couple of minutes' walk.

> > 45

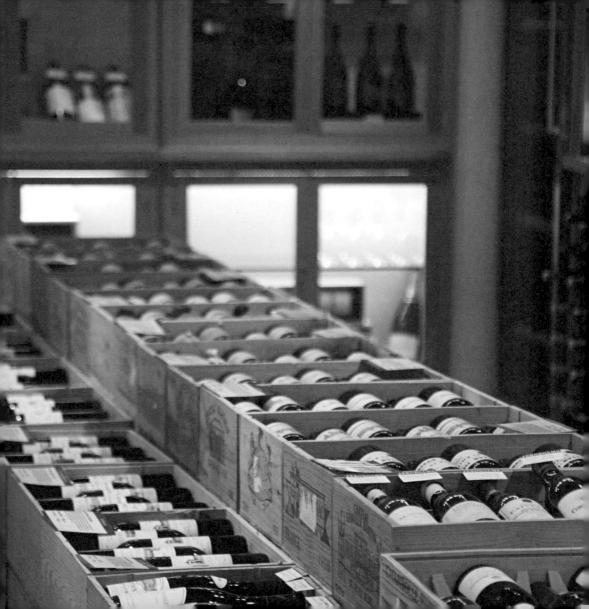

■ THE THOMAS CUBITT 44 Elizabeth St, SW1W 9PA T730 6060 www.thethomascubitt.co.uk Noon-11pm Mon-Sat; noon-10.30pm Sun This smart gastropub channels the spirit of nineteenth-century master builder Thomas Cubitt's grand stucco terraces with a regal country house-style interior. There's a bright and buzzing bar which spills out onto the street and formal dining rooms upstairs.

🕗 MUNGO & MAUD

79 Elizabeth St, SW1W 9PJ 🖀 7022 1207 www.mungoandmaud.com 10am-6pm Mon-Sat

Rather than garish squeaky toys and synthetic essentials, pet shop Mungo & Maud finds harmony between function and aesthetic with luxury cotton dog beds, wooden bowls, knitted playthings and hand-stitched leather collars.

PHILIP TREACY
69 Elizabeth St, SW1W 9PJ 2730 3992
www.philiptreacy.co.uk
10am-6pm Mon-Fri; Sat appointment only
Milliner Philip Treacy started his career on
Elizabeth Street, setting up a studio in the
late fashion icon Isabella Blow's house in 1990.
A few doors down, he continues to showcase
his incredible hats.

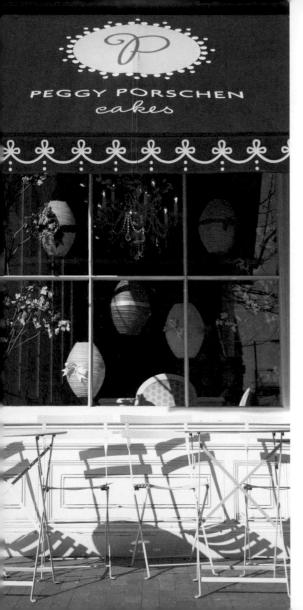

PEGGY PORSCHEN 116 Ebury St, SW1W 9QQ 7730 1316 www.peggyporschen.com 9am-6pm Mon-Sat; 10am-6pm Sun Pretty as a picture, Peggy Porschen's pink parlour serves fancy cupcakes, biscuits and cakes. Brides-to-be can discuss their showstopping tiered creation in the private boudoir and take inspiration from the stunning sugarcraft that decorates the shop's windows.

5 TOMTOM CIGARS 63 Elizabeth St, SW1W 9PP

7730 1790
 www.tomtomcigars.co.uk

 10am-6pm Mon-Wed; 10am-8pm Thu-Fri;
 10am-6pm Sat-Sun

Indulge a taste for tobacco in this specialist Cuban cigar store, where you can sample cigars on site before you buy. The shop also sells humidors, accessories and aged, limited-edition sticks, and has a sister coffeehouse further down the street.

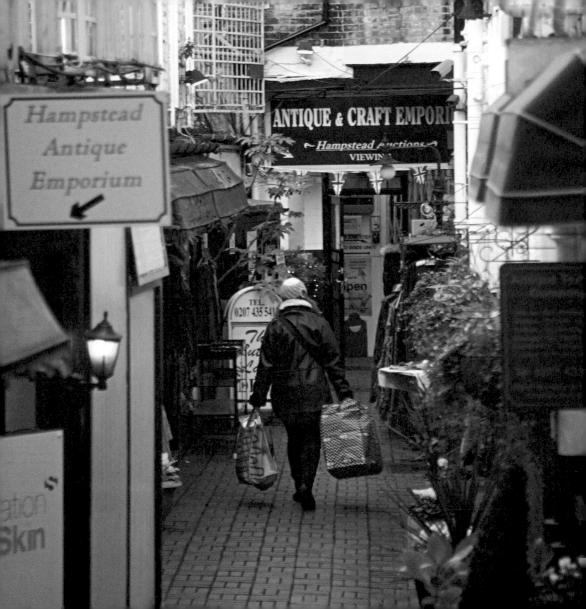

North

- PRIMROSE HILL 52
 - CROUCH END 58
- HIGHGATE VILLAGE 62
 - CAMDEN PASSAGE 68
- STOKE NEWINGTON CHURCH STREET 74
 - HAMPSTEAD VILLAGE 78

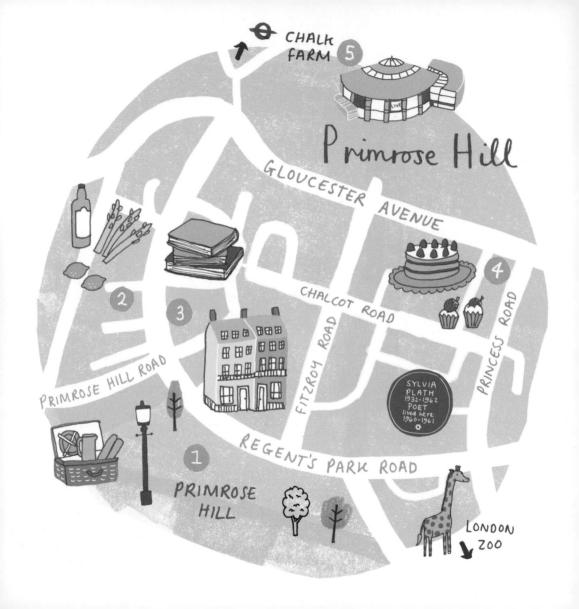

Primrose Hill

Primrose Hill residents are fierce in their support for the independent businesses along Regent's Park Road. They've fought off the arrival of a Starbucks in the past and think nothing of rallying together to protect the character of their little community. It helps that the area is often defined by its celebrities, and big names such as Jude Law, Tim Burton and Gwen Stefani have numbered among the locals. This glamorous set followed on the heels of an altogether more bohemian crowd, as the village's now multimillion-pound houses have also played home to writers including Sylvia Plath, Alan Bennett and Ian McEwan. It's easy to see the attraction: Regent's Park runs along the south of the village giving easy access to manicured lawns and London Zoo, while the more chaotic delights of Camden are just to the east. Camden's grungy

indie scene has had surprisingly little impact on the more demure Primrose

Hill. Though when Alan McGee's iconic label Creation Records moved in during the mid-1990s, it gave the peaceful area a new, electric sort of reputation fuelled by the arrival of bands including Oasis – once regulars at neighbourhood pub The Pembroke Castle.

53

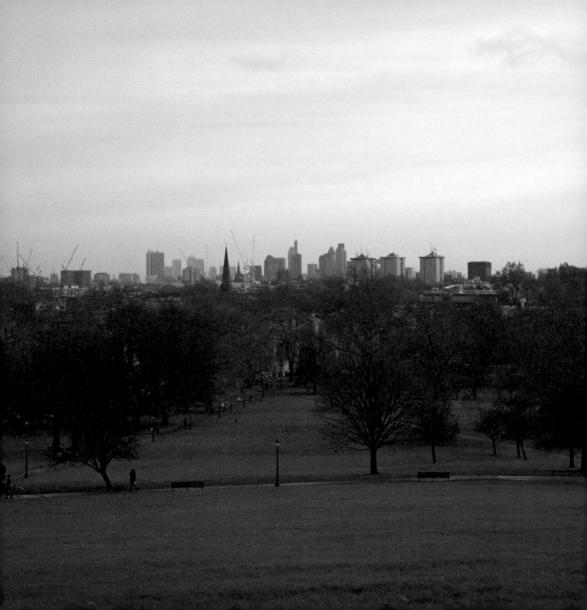

PRIMROSE HILL

● PRIMROSE HILL Primrose Hill Rd, NW3 3NA www.royalparks.org.uk 5am-9.30pm Mon-Sun

William Blake, HG Wells and Blur are among countless writers and bands to have namechecked this 250-foot hill. Kids drag their sledges up here during snowy winters, picnic blankets dot the park in summer, and people perennially make their way to the summit for panoramic views of the city.

SHEPHERD FOODS

59-61 Regent's Park Rd, NW1 8XD 27586 4592

8am-11pm Mon-Sun

A real local asset, this large delicatessen is geared toward those with a refined palate, and its sister deli, Partridges, holds a Royal Warrant for its dedication to supplying the Queen's larder. Shepherd has a decent wine selection and hotfood counter, making it a great stop before a picnic in the park.

PRIMROSE HILL

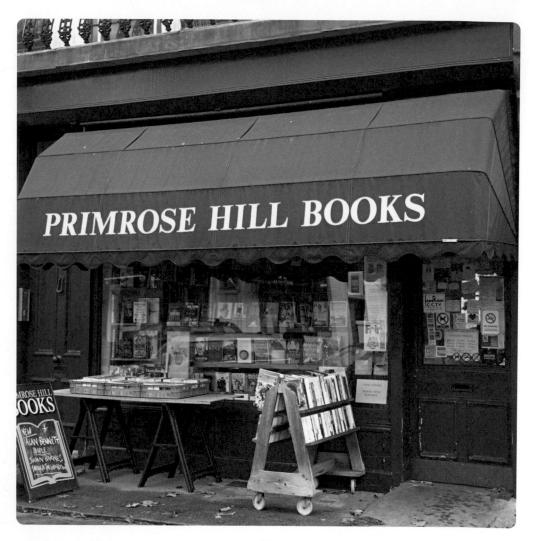

PRIMROSE HILL BOOKS

134 Regent's Park Rd, NW1 8XL 7586 2022
www.primrosehillbooks.com 9.30am-6pm Mon-Sat; 11am-6pm Sun Feeding the minds of Primrose Hill's literary types, this family-run bookshop is on friendly terms with local authors (this area has a rich literary heritage), and signed books can often be found here. Founders Jessica Graham and Marek Laskowski (together with their knowledgeable team) also organise a series of lectures each year that feature some starry names.

PRIMROSE BAKERY

69 Gloucester Avenue, NW1 8LD 🖀 7483 4222

- www.primrose-bakery.co.uk
- 9am-5pm Mon-Sun

Slightly removed from the Hill's main retail hub, the joyously retro Primrose Bakery is worth a detour. It's a darling little café serving impeccable cupcakes, cola floats and cookies, as well as the sorts of celebration cakes that make a party.

5 ROUNDHOUSE Chalk Farm Rd, NW1 8EH 🕿 7424 9992

🗟 www.roundhouse.org.uk

The cylindrical Roundhouse was originally built as a train turntable shed in the 1840s before becoming an arts centre in the 1960s. It's undergone various reincarnations and refurbishments since, but has famously seen Jimi Hendrix, Pink Floyd and the Ramones take to the stage. Today, it programmes a mix of theatre, music and performance art.

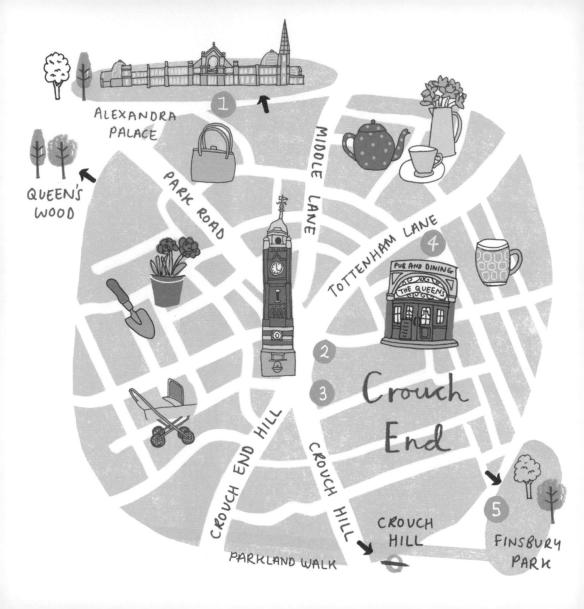

Crouch End

Although Crouch End can feel a little removed from the city centre, with no tube and limited bus and rail links, its remoteness is largely its attraction. Young families love to set up home in this hilly neighbourhood, essentially hoping to live a suburban lifestyle without actually having to leave London. And the plan works quite well. Crouch End is a very complete village, with amenities catering for every need, be it bistro dining or bedding soil from

the high street garden centre. Its popularity with parents means the roads surrounding its central clocktower also have a remarkably high concentration of children's boutiques and parent-filled cafés – though there's far more to the area than just shopping and eating. Dominated by farm- and hamlet-studded woodland until the late nineteenth century, Crouch End still boasts patches of forest (such as Queen's Wood a mile to the west), while the dominance of

Victorian architecture reflects its era of boom and growth. The most noteworthy period building is the mighty Alexandra Palace: some 300 feet above sea level and surrounded by 196 acres of parkland, it's a must-visit if you're heading this far north.

ALEXANDRA PALACE

Alexandra Palace Way, N22 7AY

☎ 8365 2121 ... www.alexandrapalace.com Things didn't start well for Ally Pally: the 'People's Palace' was opened to much fanfare in 1873, but promptly burnt down just sixteen days later. It was rebuilt within two years and went on to become a transmitting centre for the BBC from the 1930s to the 1950s. Day-trippers come for peerless views over London, or to visit its cafés, ice-rink, deer enclosure, pitch-and-putt course and glorious boating lake.

2 THE HOUSE OF BOOKS 42 The Broadway, N8 9SU

🖀 8340 7080

www.thehouseofbooks.co.uk 9.30am-6.30pm Mon-Sat; 11am-6pm Sun That this bookshop is often bustling with browsing customers is testament to its switchedon staff who care enough to keep on top of the best new reads, as well as sharing their top picks across the genres. There are further branches of this indie chain in nearby Muswell Hill and further afield in West Hampstead (both great villages in their own right).

136 Crouch Hill, N8 9DX 🖀 8340 8221 www.coffeecircus.co.uk 8am-6pm Mon-Sat; 9am-6pm Sun Crouch End is blessed with an abundance of good cafés and Coffee Circus numbers among them. There's a simple breakfast and lunch menu, but it's the lovingly made coffee that's the star.

🚯 THE QUEENS

26 Broadway Parade, N8 9DE 🖀 3978 2154 www.brunningandprice.co.uk Noon-11pm Sun-Thu; noon-midnight Fri-Sat As grand a pub as you'll find in London, The Queens was built as a Victorian hotel and watering hole for Crouch End's refined middle class. Its spectacular stained glass, decorated plaster ceilings and original screened alcoves are lavish, but this is now a very down-to-earth pub.

B PARKLAND WALK

Walk begins at Oxford Rd, N4 3EY www.parkland-walk.org.uk Dawn-dusk Mon-Sun

This fantastically atmospheric three-mile walk runs from Finsbury Park to Alexandra Palace via a disused train line and is an ideal route if you're planning to explore the area. Follow the wooded path as it rears up over the chimney pots and dips down past abandoned platforms.

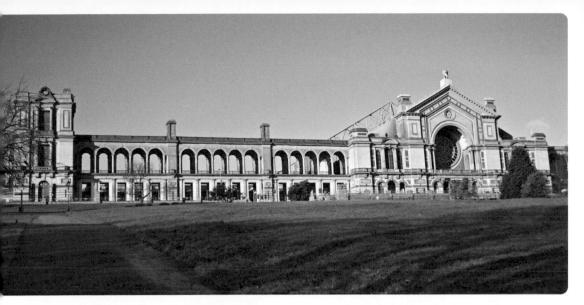

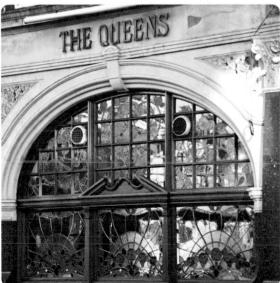

HIGHGATE -lighgate Village HAMPSTEAD LANE Fr HIGHGATE HIGH STREET PONO SQ. Kenwood House HIGHANTE HILL 50UTH GROVE 1000 Innolag Innon SWAINS ß WATERLOW PARK LANE HIGHGATE HAMPSTEAD CEMETERY HEATH

Highgate Village

Bordering the eastern side of Hampstead Heath and sheltered by woodland, Highgate has long been popular with countryside-craving urbanites looking for a haven within the city. The village's hilltop setting and elevated vantage points have helped give its streets an exclusive air, and the tree-lined lanes and their period mansions have famously played home to poets including Samuel Taylor Coleridge and John Betjeman, as well as musicians George Michael and Ray Davies. But for all its seclusion, historic charm and wealth, this quintessential London village hasn't managed to avoid an influx of chains, and a few faceless coffee shops, supermarkets and pizza restaurants punctuate the high street. Thankfully, they're neatly hidden behind pretty Georgian shopfronts and caught between more appealing local stores and village pubs. One of the best, The Flask, is a distinctive eighteenth-century drinking den which neighbours the picturesque Pond Square (a plaza which hosts community fairs and carol singing) and St Michael's – a grand neo-Gothic church that stands higher than any in London.

HIGHGATE CEMETERY Swain's Lane, N6 6PJ 28340 1834 www.highgatecemetery.org 10am-5pm Mon-Sun

This working, Grade I-listed cemetery split into two parts is one of the most dramatic locations in London. Overgrown tombs, moss-covered statues and extraordinary vault formations (look out for the Circle of Lebanon) have made it a site of Victorian Gothic pilgrimage. Stick to the east for the graves of Karl Marx and Douglas Adams, or join a tour to explore the west side's rugged terrain where Michael Faraday and the family of Charles Dickens are interred.

WATERLOW PARK Highgate Hill, N6 5HF www.waterlowpark.org.uk Dawn-dusk Mon-Sun

Once a private estate, this 29-acre plot was donated to the public by Sir Sydney Waterlow in 1889 as a 'garden for the gardenless'. Its undulating lawns, formal bedding, spring-water ponds and noteworthy trees are a match for any royal park. The on-site sixteenth-century Lauderdale House (which operates as an arts centre) adds further historic gravitas.

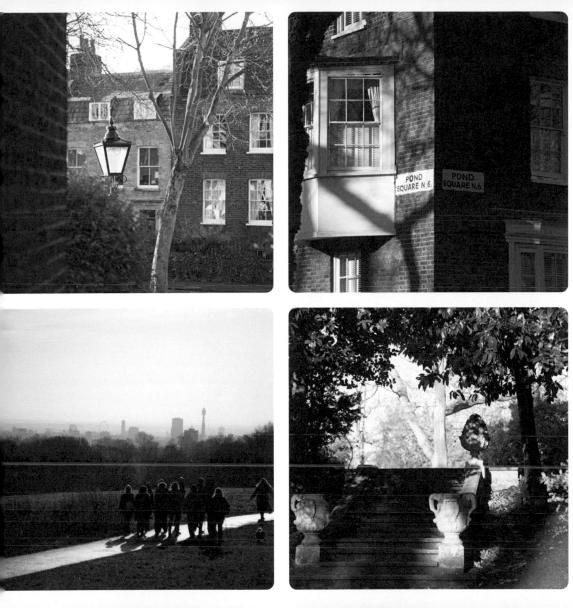

HIGHGATE VILLAGE

HIGHGATE LITERARY & SCIENTIFIC INSTITUTION
 South Grove, N6 6BS
 8340 3343 Www.hlsi.net
 Mam-5pm Tue-Fri; 10am-4pm Sat
 Established in 1839, this unusual institution continues to keep locals on their cultural and intellectual toes with a programme of challenging film, art, lectures and music. Its library packs in some 26,000 books and an archive of Highgate history.

ELECTRIC DAISY FLOWER FARM
 Swain's Lane, N6 6AG
 8348 3162
 www.electricdaisyflowerfarm.co.uk
 9am-5pm Tue-Sat; 9am-2pm Sun
 A heart-lifting show of British-grown flowers
 draw you into this vibrant shop. The blooms come
 straight from its Somerset farm and the resulting
 bouquets are fragrant, fabulous and refreshingly
 seasonal. As well as floral treats, this store stocks
 a range of lovely gifts.

5 KENWOOD HOUSE Hampstead Lane, NW3 7JR 3 0370 333 1181 Www.english-heritage.org.uk This English Heritage-run Georgian mansion is perched on a knoll on Hampstead Heath looking out over a tranquil lake. Basking bodies speckle its lawns come summer, though the real treasures are inside where an art collection features work by Rembrandt, Gainsborough, Vermeer and Turner.

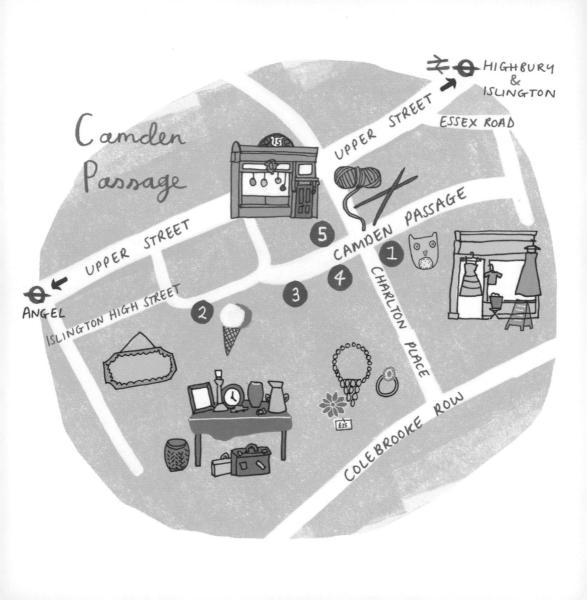

Camden Passage

Though not a defined village in the traditional sense, Camden Passage is distinct enough to provide a picturesque antidote to Islington's sometimes homogenous Upper Street which runs parallel. The mid-eighteenth-century lane became a hub for antiques in the 1960s, and though the number of traders has declined in recent years, some 150 dealers still display their wares come Wednesday and Saturday market days. There's also a strong vintage and antiques focus to the permanent independent businesses that line the alleyway, with plenty of retro furniture, secondhand clothes and decorative homeware and jewellery to shop for. The compact passage also has a number of good eateries, and droves of people flock here at the weekends hoping to bag a table for brunch at The Breakfast Club or buy a wedge of cheese from Pistachio & Pickle. If you'd rather avoid the hustle, it's best to visit mid-week when the clamour mellows and the shopping streets around this little road also become more pleasant to explore.

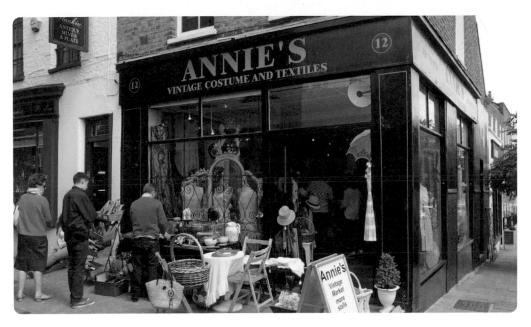

ANNIE'S

12 Camden Passage, N1 8ED 7359 0796 www.anniesvintageclothing.co.uk 11am-6pm Mon-Sun

There's always a tempting rail of silky vintage items outside this long-serving boutique. Head inside for an opulent and girly mix of mink pelts, beaded and sequined 1920s dresses and antique lace at all price points. It's said to be a favourite among fashion designers and models, so you might spot someone fabulous, too.

REDEMPTION ROASTERS 96–98 Islington High Street, N1 8EG www.redemptionroasters.com 7am-6pm Mon-Fri; 8am-6pm Sat-Sun There's no doubt you'll get a great coffee here and there's loads of stylish space to sit (there's even a little courtyard garden). But better yet, Redemption Roasters works with ex-offenders, training them in roastery and barista skills. With several outposts across London (including King's Cross, Bloomsbury and Barbican), it is becoming ever more successful in its mission to help people.

PIERREPONT ARCADE Pierrepont Row (off Camden Passage), N1 8EG 27359 0190 www.camdenpassageislington.co.uk Shop: times vary. Market: 9am-6pm Wed; 8am-6pm Sat

A cluster of cupboard-sized shops make up this quaint antiques arcade, with further dealers manning stalls at its entrance on market days. Each is dedicated to a specific product, from jewellery to glassware, making this an ideal place to get expert advice on buying antique clocks, oriental porcelain, period vases, military memorabilia and so much more.

🚯 KIPFERL

20 Camden Passage, N1 8ED 27704 1555
www.kipferl.co.uk 10am-10pm Mon-Thu; 10am-11pm Fri-Sat; 10am-7pm Sun Somewhat under-represented in London,

Austrian food has found a champion in Kipferl. The café and restaurant has a sleek aesthetic and turns out classic dishes together with smooth Viennese coffee served the traditional way: on a metal tray with a glass of water. For lunch and dinner, try a belly-warming goulash or Wiener schnitzel.

LOOP 15 Camden Passage, N1 8EA

 7288 1160
 www.loopknittingshop.com

 Noon-5pm Wed-Sun
 More than just a yarn shop, Loop
 fosters a craft community. Its monthly
 SOS drop-ins help knitters in a bind
 and its knitting and crochet classes
 cater for beginners and improvers. The
 shop itself brings together a medley
 of colourful yarns, interesting patterns
 and beautiful gifts made by skilled
 knit, crochet and felt designers.

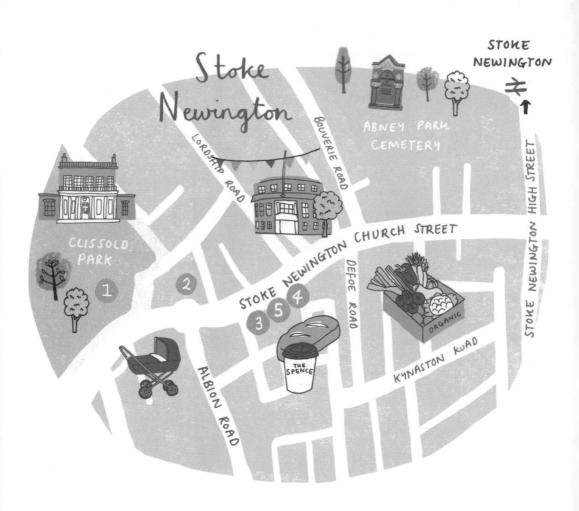

Stoke Newington Church Street

You'd be hard pushed to find a London village with a more proactive community than Stoke Newington. Locals are quick to club together to launch campaigns against big businesses trying to move into the indie-spirited Church Street, and they support myriad events from craft fairs in Abney Public Hall to the all-organic Saturday farmers' market at St Paul's Church. Keeping it local – and keeping it green – is a primary concern for Stoke Newington's residents, and not-for-profit initiatives (such as the brilliant organic veg-box scheme Growing Communities) tend to flourish. This type of social enterprise makes Stokey an attractive option for young families, and you might well be shunted off the pavement by pram congestion if you arrive on a busy weekend. Luckily, there are copious places to dive into until the rush has died down. Pubs The Three Crowns and The Jolly Butchers are at the heart of the village, as is laidback restaurant The Good Egg. Come evening, evidence of an overspill from nearby nightlife hub Dalston becomes obvious, as a handful of clubs and bars keep revellers going.

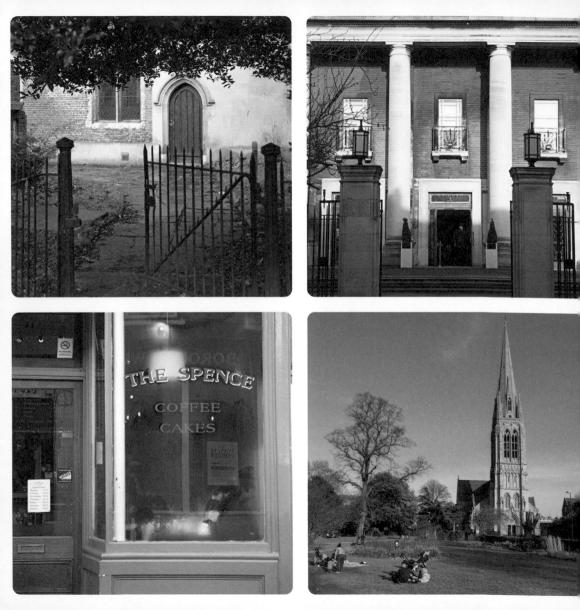

STOKE NEWINGTON CHURCH STREET

CLISSOLD PARK

STOKE NEWINGTON TOWN HALL

Stoke Newington Church St, N16 OJR 8356 5505 Www.hackneyvenues.com This beautiful Art Deco town hall was once where the cool kids would spend their nights tearing up the dancefloor in the Assembly Hall. These days, it's a hub for wedding ceremonies, but keep an eye on the events calendar as it also hosts comedy and concerts, talks and more.

THE SPENCE BAKERY & CAFÉ 161 Stoke Newington Church St, N16 0UH 7249 4927 www.thespence.co.uk 8am-5pm Tue-Sun

The Spence has been baking its moreish loaves and buns since 2002 and still has a loyal fanbase. Stop in for seasonal bakes and lovely cakes. SEARCH AND RESCUE
 Stoke Newington Church St, N16 OUH
 3302 8658
 www.searchandrescuelondon.co.uk
 10am-6pm Mon-Sun
 The stock is hugely varied in this boutique, from homeware to jewellery via candles and stationery. The common thread is a sense of style: it is all invariably lovely. You'll want one of everything, so enter prepared to spend.

S NOOK

153 Stoke Newington Church St, N16 0UH 249 9436 Www.nookshop.co.uk 10am-5pm Mon-Fri; 10am-6pm Sat; 11am-5pm Sun

You'll find several Stokey stores selling interesting homeware, but this boutique is particularly worth noting. The emphasis is on beautifully designed products, be it an ever-useful dustpan and brush, Scandi-style furniture, screenprints by local artists or handmade ceramics.

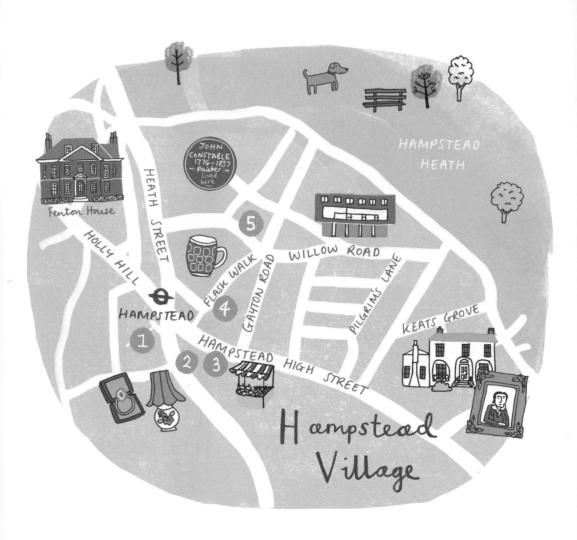

Hampstead Village

One of London's most iconic villages, lofty Hampstead looks like it's been sliced straight out of the countryside. Narrow, winding lanes and Victorian cottages provide bucolic character, while its more-than-fair share of historic attractions ensure Hampstead is never forgotten as a key London destination. Two National Trust properties provide some of the area's most prized gems: Fenton House - a seventeenth-century merchant's townhouse famed for its period furnishings and enchanting walled garden - and 2 Willow Road, a modernist villa that reveals more about Hampstead's artsy and intellectual 1930s heyday. This property (originally home to architect Ernö Goldfinger, a name famously borrowed by disgruntled neighbour and Bond author Ian Fleming) is particularly recommended, brimming as it is with art and furniture by luminaries including Henry Moore and Max Ernst. It's also just tripping distance from Keats House, and the former homes of John Constable, DH Lawrence and Stanley Spencer are also nearby. In fact, the network of roads either side of Hampstead's now largely chain-filled high street are teeming with literary and artistic heritage, and it's worth arriving armed with a Blue Plaque guide.

HAMPSTEAD VILLAGE

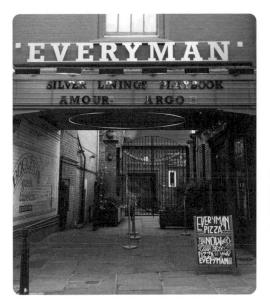

EVERYMAN CINEMA 5 Holly Bush Vale, NW3 6TX © 0872 436 9060

www.everymancinema.com

Opened in 1933, this outpost of the boutique Everyman cinema chain is one of the oldest movie theatres in the UK. It's also one of the most sophisticated, with two-person sofas, an alcohol licence and waiter service.

HAMPSTEAD ANTIQUE AND CRAFT EMPORIUM

12 Heath St, NW3 6TE 27794 3297 www.hampsteadantiqueemporium.com 10.30am-5.30pm Tue-Fri; 10am-6pm Sat; 11am-5.30pm Sun

More than twenty dealers man their own cubbylike spaces in this ramshackle and old-fashioned emporium which opened in 1967. The early noughties saw craftmakers join the sellers, and you'll now find handmade jewellery and ceramics alongside vintage furniture, textiles and toys.

HAMPSTEAD VILLAGE

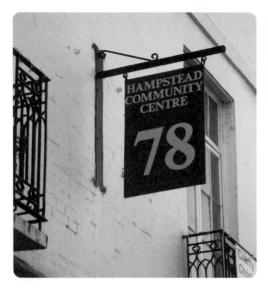

HAMPSTEAD COMMUNITY CENTRE 78 Hampstead High St, NW3 1RE 7794 8313

☐ www.hampsteadcommunitycentre.co.uk Events and hours vary

A covered and outdoor market routinely operates here on Saturdays and/or Sundays. When food is its focus, a grocer, butcher and fishmonger are joined by food traders. There are also artisanal, seasonal market days with local crafts, antiques and bric-à-brac. Outside of market days, it's a hub for the community, with an after-school club and various kids' events.

🚯 THE FLASK

14 Flask Walk, NW3 1HE 27435 4580 www.theflaskhampstead.co.uk 11am-11pm Mon-Sat; noon-10.30pm Sun Occupying a historic plot where fresh water was bottled and sold in the early eighteenth century, the Grade II-listed Flask was built on the site of the Thatched House pub in 1874. As well as commemorating the location's heritage, the pub offers up its own antiquities, with original glass screens, and panels painted by Belgian artist Jan van Beers.

HAMPSTEAD VILLAGE

S BURGH HOUSE & HAMPSTEAD MUSEUM New End Square, NW3 1LT [∞] 7431 0144 [∞] www.burghhouse.org.uk ¹0am-4pm Wed-Fri, Sun ¹his Grade I-listed house was built as a residence in 1704, turned into a British militia HQ in the mid-nineteenth century and was home to Rudyard Kipling's daughter in the 1930s. all before becoming a community hub

1930s, all before becoming a community hub some twenty years later. In 1979, it was restored and transformed into a museum and arts centre that celebrates the colourful history of Hampstead Village.

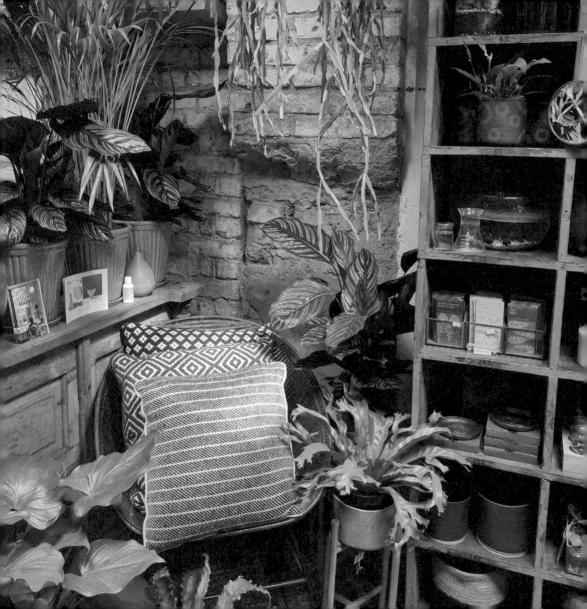

South

EAST DULWICH • 86 BELLENDEN ROAD • 92 BRIXTON VILLAGE • 98 CHELSEA GREEN • 102 NORTHCOTE ROAD • 108 ABBEVILLE VILLAGE • 114

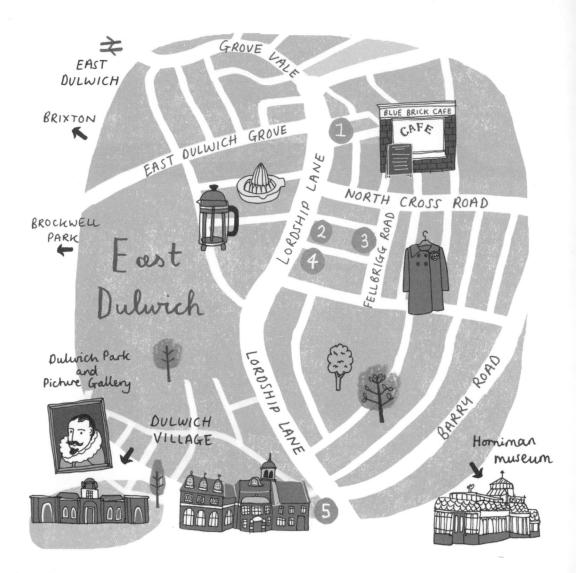

East Dulwich

Part of a vast, leafy south London suburb bookended by Brixton and Peckham, East Dulwich is one of several local villages and attractions. Note that the distances between each can be off-putting if you're walking, so it's best to make a transport plan if you want to head down for the day and take in the Art Deco lido at Brockwell Park, the anthropological Horniman Museum and Gardens, and the bucolic Dulwich Village and Dulwich Picture Gallery – a majestic Regency building housing an impressive collection of Old Masters. Leave plenty of time for East Dulwich, however, as it hosts the area's largest concentration of shops and eateries. The main mishmash of retail can be found along the mile-long high street Lordship Lane, though the far quieter side street North Cross Road is also a hotspot. A sort of village in itself, it is home to the popular Blue Mountain Vegan (at number 18) and, about three minutes along the road, the vintage emporium ChiChiRaRa (on the corner at 40b Hindmans Road). It also lays on a fashionable Saturday market made up of retro clothes stalls and vendors selling hot and fresh food.

● FOREST 43 Lordship Lane (corner of Frogley Road), SE22 8EW www.forest.london 10am-6pm Mon-Sat; 11am-4pm Sun A plant lover's heaven, Forest is packed with thriving houseplants from towering tropicals to tiny cacti and succulents. There are loads of unusual species to choose from, and a great mix of other goods, from pots and plant books to artisan chocolate and luxury candles. You'll find another branch in Deptford Market Yard (which itself is a top mini-village).

ROULLIER WHITE
 125 Lordship Lane, SE22 8HU
 8693 5150
 www.roullierwhite.com
 9.30am-5.30pm Mon-Sat; 11am-5pm Sun
 If you tend to reach for the bicarb and vinegar
 when a household emergency strikes, you'll
 love Roullier White's line of traditional
 and practical household products. Among
 nostalgically packaged laundry detergent,
 furniture polish and washing-up liquid, the store
 stocks grooming essentials, perfumes, luxury
 gifts and homeware.

BLUE BRICK

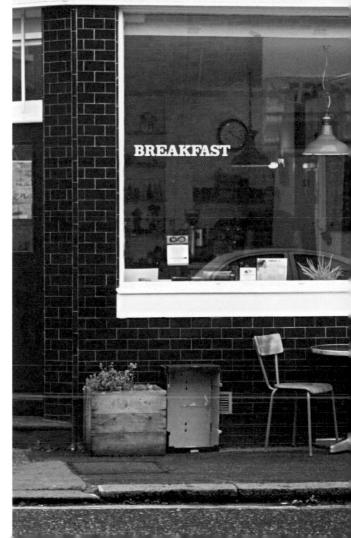

BLUE BRICK CAFÉ 14 Fellbrigg Rd (off North Cross Rd), SE22 9HH 28299 8670 www.bluebrickcafe.com 9am-5pm Mon, Wed-Sun There are many top-notch cafés nestled on and around Lordship Lane, but this slightly out-of-theway establishment deserves special mention. Clad in blue tiles and on a residential road, the café serves a vegetarian and vegan all-day menu in what looks like grandma's kitchen. Stop in for cake and coffee, or bring your own bottle to pair with stews and salads.

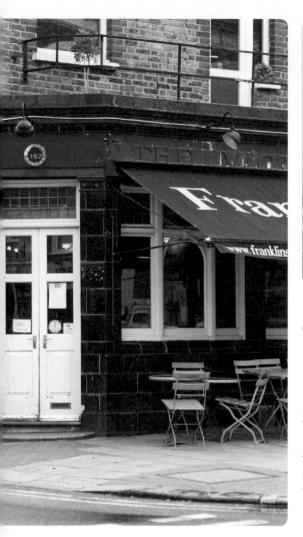

FRANKLINS
 157 Lordship Lane, SE22 8HX
 8299 9598
 www.franklinsrestaurant.com
 11am-midnight Mon-Fri; 10am-midnight
 Sat; noon-10.30pm Sun
 There's no shortage of places to eat in East
 Dulwich, but none have quite the dedication
 to localism as Franklins. The restaurant's menu
 makes use of fresh produce from Kent, meat
 from rare-breed farms and seafood fished from
 British waters.

S DULWICH LIBRARY
 368 Lordship Lane, SE22 8NB

 [∞] 7525 2000
 [∞] www.southwark.gov.uk
 10am-6pm Mon-Fri;
 10am-5pm Sat
 Established In 1897, this grand,
 redbrick library doubles up as a
 community hub hosting adult reading
 groups (from manga to poetry), as well
 as toddler mornings, after-school clubs,
 film matinées and craft workshops.

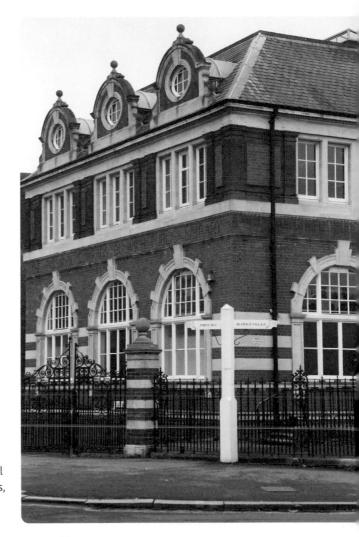

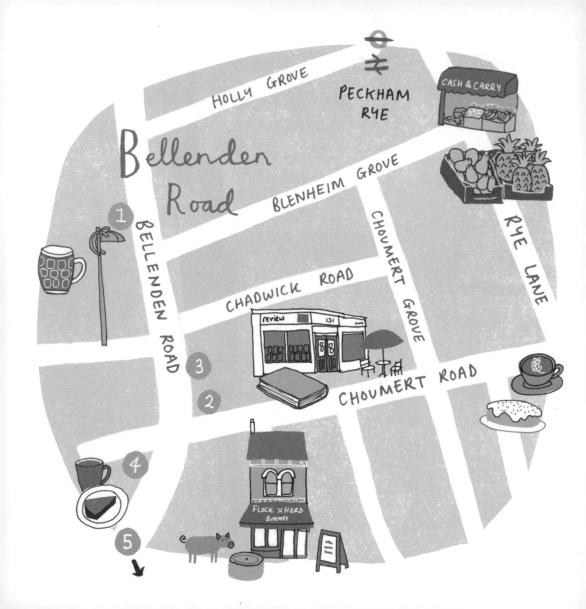

Bellenden Road

This serene, boutique-lined road vies for attention in an area best known for Rye Lane, a street where global grocery stores, fabric shops and hair salons butt up against familiar high street brands and the odd pop-up bar (usually frequented by art school students from the nearby Camberwell College). Wander off Rye Lane and you'll find the sleepy Bellenden Road, where genial shopkeepers, cute cafés, essentials (like butchers Flock & Herd at number 155)

and welcoming pubs are all lined up. Independently owned boozer The Montpelier on Choumert Road has a dinky cinema in its backroom and serves local brews, while The Victoria Inn back on Bellenden is at the heart of the village with a dog-friendly policy, live music, pub quiz and a great Sunday roast. Ensure you have enough time to explore the surrounding area: look out for arts centre The Bussey Building at 133 Rye Lane, Persian deli Persepolis at 28 Peckham High Street, and the café-cum-gallery that pops up on top of the Peckham Rye Multistorey Car Park each summer.

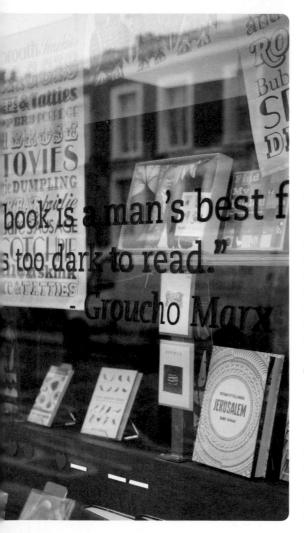

A great beer shop connected to the barrel room of independent micro-brewery Brew By Numbers – the room houses their specialist aged beers and sours that are fermenting in oak casks. The brewery also has a taproom in Bermondsey where you can try the beer at its freshest.

REVIEW

131 Bellenden Rd, SE15 4QY 🖀 7639 7400 www.reviewbookshop.co.uk 10am-5pm Wed-Sun

This excellent bookshop encourages a 'balanced reading diet' by stocking a generous number of short story and poetry collections among novels and non-fiction. The shop is a pivotal part of the annual Peckham Literary Festival and also hosts regular in-store events.

GATHER 121 Bellenden Rd, SE15 4QY www.wearegather.uk 10am-7pm Mon-Fri; 10am-6pm Sat; 10.30am-4.30pm Sun This organic refill store is on a mission to help you live better and leave less of an impact on the planet. Its shelves are lined with handsome jars filled with grains, nuts, spices and other store-cupboard essentials that you can scoop into your own reusable containers. There are also other handy essentials among a range of non-toxic cleaning products and toiletries.

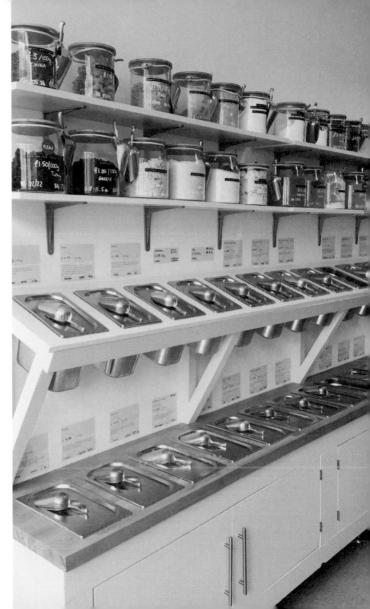

THE BEGGING BOWL 168 Bellenden Rd, SE15 4BW 7635 2627 www.thebeggingbowl.co.uk 6pm-10pm Tue; 5pm-10pm Wed-Thu; noon-2.30pm & 5pm-10pm Fri-Sat; noon-4pm Sun

Thai street food is brought indoors by regional food expert and chef Jane Alty in this colourful, contemporary restaurant. The atmosphere is jumping in the evenings, when busy tables are topped with small bowls (stir-fries, soups, grills and curries) designed for sociable sharing.

MELANGE CHOCOLATE SHOP & CAFÉ 2 Maxted Rd, SE15 4LL

www.themelange.com

12.30pm-6pm Thu-Fri; 11am-6pm Sat-Sun Bowls of sample chocolate are lined up along the counter here, inviting you to try inventive flavour combinations that take in spices and botanicals such as ginger and lime, cardamom and clove, or salted caramel and juniper. The chocs (or a heavy slice of cake) can be wrapped up to go, or you can learn more about the infused Belgian sweets at Melange's tasting and making workshops.

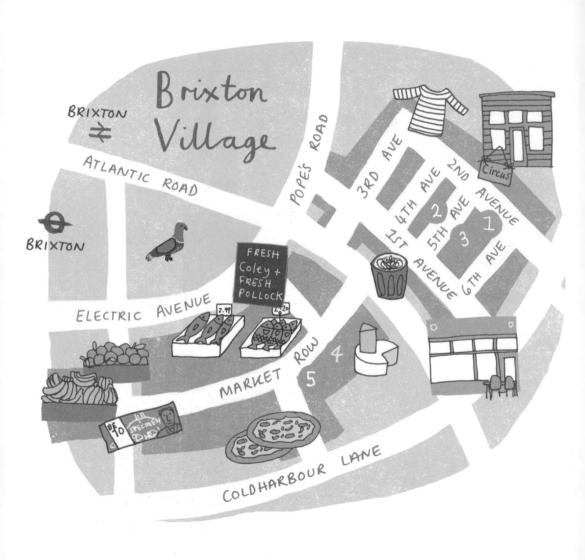

Brixton Village

The late-noughties revival of Brixton Village and the adjacent Market Row kickstarted a new era for this once depressed south London quarter. At the time, the arched arcades (parts of which were installed as early as the 1930s) were in desperate need of tenants and repair, and a campaign to encourage new business through low rents managed to entice a handful of resourceful locals with bright ideas to set up shop. Within a couple of years, the two covered passageways had become a London hotspot, and now dozens of restaurants, cafés and boutiques jostle alongside the arcades' Caribbean delis, fresh fish stalls and African textile shops. This multicultural urban village continues to be a much-visited destination and although a few chain restaurants have crept in, independent businesses - such as larder shop Cornercopia (which only stocks locally sourced foods), and Le Brixton Deli - are plentiful. Regular shoppers have been known to use the Brixton Pound a private currency which helps money stay within the village - and the sociable market community is always game for organising parties and late-night shopping events, or simply pointing you in the direction of one of the arcades'

many entry and exit points.

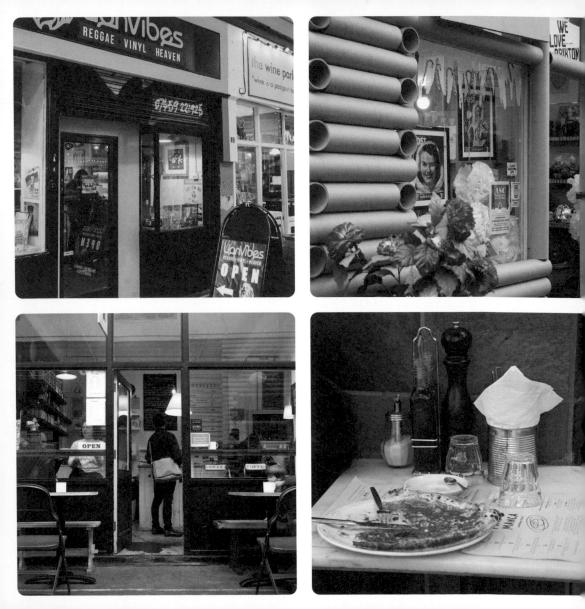

LION VIBES

98 Granville Arcade, SW9 8PS www.lionvibes.com 11am-6pm Mon-Sat; 11am-4pm Sun A purveyor of Jamaican music that specialises in reggae and dub vinyl, Lion Vibes sells vintage records from the mid-twentieth century to today, as well as new releases.

Q CIRCUS

79 Brixton Village, SW9 8PS www.circusbrixton.com 11am-5.30pm Mon-Wed, Sun; 11am-6pm Thu-Fri; 10.30am-6.30pm Sat Tabitha Rout and Binki Taylor, owners of this compact boutique, champion local artists with unrelenting dedication. They keep the Circus shelves stocked with an ever-changing line-up of handmade ceramics, cards, jewellery and art by practitioners who live within a five-mile radius of the store – and they make sure price tags remain affordable.

S FEDERATION COFFEE Unit 77–78, Fifth Avenue, SW9 8PS www.federation.coffee 8am-5pm Mon-Wed; 8am-late Thu-Fri; 9am-late Sat; 9am-4pm Sun Run by two Kiwis, Federation was one of the originators of Brixton Market's current boom and its popularity has seen it up size to larger premises. Its success rests on its locally roasted coffee and freshly baked cakes and pastries.

G SALON

18 Market Row, SW9 8LD 27501 9152 www.salonbrixton.co.uk Noon-3pm & 5.30pm-10pm Wed-Sat; 3.30-10pm Tue; noon-3pm Sun This wine shop, café and bar (which started life as a cheese shop) has always celebrated British ingredients which are sourced from as close as London and as far as the Scottish Highlands. The menu gives it all an international spin and you can expect a dish of Cornish leeks, Tunworth cheese and barley, or Berkswell gnudi, courgette, tomato and olive.

FRANCO MANCA

4 Market Row, SW9 8LD 27738 3021 www.francomanca.co.uk Noon-10pm Mon-Thu; noon-10.30pm Fri; 11.30am-10.30pm Sat; 11.30am-10pm Sun One of the first restaurants to put Brixton Village on the map, Franco Manca opened this first branch in 2008. Since then, its sourdough pizzas have become so popular that you'll see branches of the restaurant all over I ondon. This one retains its indie vibe.

Chelsea Green

Tight-lipped residents don't like to reveal too much about this locale, preferring to preserve the peace of their secret village. To their credit, they've done a marvellous job – many Londoners are clueless about Chelsea Green's existence, missing out on an intimate little neighbourhood with a traditional squared-off lawn at its centre. The roads facing the green – and additionally Elystan Street – are where you'll find a small number of boutiques, bars and grocers supplying high-grade essentials.

Look out for gourmet food shop The Pie Man, the acclaimed Chelsea Fishmonger, Jago Butchers and wine shop Haynes, Hanson & Clark. Just a short walk away, there's an even better reason to visit, as Sydney Street reveals the magnificent St Luke's & Christ Church. The imposing neo-Gothic, nineteenth-century building is proud of its heritage: Charles Dickens married Catherine Hogarth here on April 2 1836, just two days after publication of his first instalment of the Pickwick Papers.

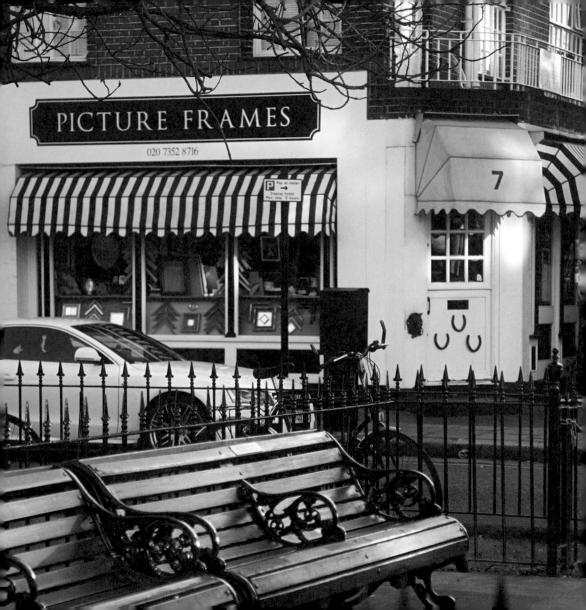

FELT

53 Godfrey St, SW3 3SX 🖀 7349 8829 www.feltlondon.com 10.30am-5pm Tue-Sat

A cult favourite, and beloved by celebrities, this tiny shop is crammed with an unusual mix of vintage and new costume and fine jewellery. The cherry-picked selection sits alongside an oddball mix of ever-changing gifts from rare books and antique ceramics to colourful cashmere scarves. If you're strapped for cash, you can bring along a piece of jewellery you no longer wear, and barter it for store credit.

2 WILD TAVERN

2 Elystan St, SW3 3NS 🖀 8191 9885 www.wildtavern.co.uk Noon-3pm & 5-10pm Mon-Sat; noon-3pm & 5-9.30pm Sun

Informal (in a smart, Chelsea sort of way), this Mediterranean restaurant focuses on seafood and meat, and offers a raw bar, together with a short menu of fish and meat steaks. Leaning heavily toward Italian, there's also a lovely pasta menu (ideal if oysters and T-bones aren't your thing).

3 AMAIA KIDS 14 Cale St, SW3 3QU ☎ 7590 0999 www.amaiakids.co.uk 10am-6pm Mon-Sat

You won't find the typical dinosaur/tractor/ flower-print tees and frocks at this kidswear store. Designer Amaia Arrieta (from Spain, where the clothes are made) prefers a more traditional look, and collections feature soft hues, classic cuts and retro details. It's a style that has the royal seal of approval (Prince William's children have been known to sport Amaia pieces), while the price tags are relatively everyday.

CHELSEA GREEN

ROBINSON PELHAM 39 Elystan St, SW3 3NT T 7828 3492 www.robinsonpelham.com 10am-5.30pm Mon-Fri

Jewels – in every colour, size and shape – are a speciality at this couture boutique. As well as a bespoke service that invites you to commission your own unique showstopping plece, there are two ready-to-wear collections: a classic range with a grown-up but still glitzy feel, as well as a contemporary and boldly progressive collection. Go prepared to spend thousands (not hundreds), alternatively treat this as a great place to practise self control.

PAINT & PAPER LIBRARY 3 Elystan St, SW3 3NT 27823 7755 www.paintandpaperlibrary.com 9am-5pm Mon-Fri

Joining a run of interiors specialists on Elystan Street, David Oliver's Paper & Paint Library is devoted to pairing harmonious hues for effortless home-decorating. Each emulsion and wallpaper shade is uniquely created by David, who travels the world looking for colour inspiration.

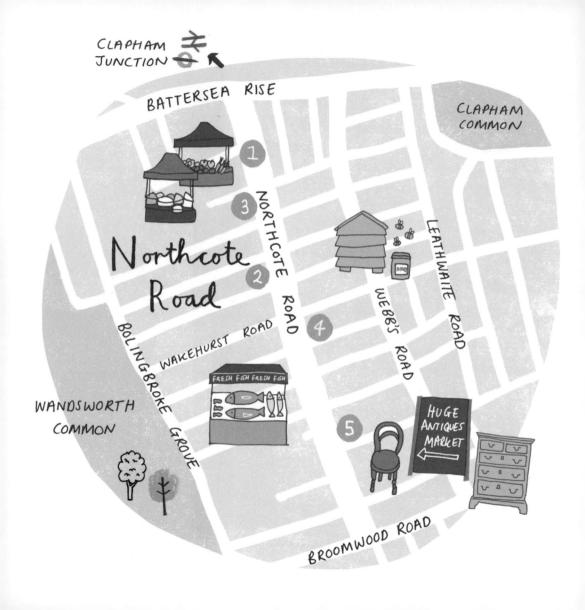

Northcote Road

Once farmland and fields of lavender, this area of Battersea blossomed following the advent of Victorian railways and industrialisation. Terraces sprouted around key thoroughfares, and the Falcon Brook (whose route ran along the path of Northcote Road) was lost from the landscape. As the population grew, so did small shopping enclaves such as Northcote Road: it was here that locals would run grocery errands to the butchers, bakers and fishmongers, as well as the then famous fruit and veg market. The road changed with the times during the twentieth century, but has always retained its market tradition and continues to foster independent business, both foodie and otherwise. For the best boutiques and cafés, it pays to head away from Clapham Junction's high street and toward the lower end of Northcote Road. Make an effort to walk over to the parallel (and far quieter) Webb's Road too, where there's a small congregation of shops and eateries. If you're all shopped out, try Battersea Rise to the north for a decent bar, or head east or west to hit green space: Northcote Road is sandwiched between Wandsworth Common and Clapham Common.

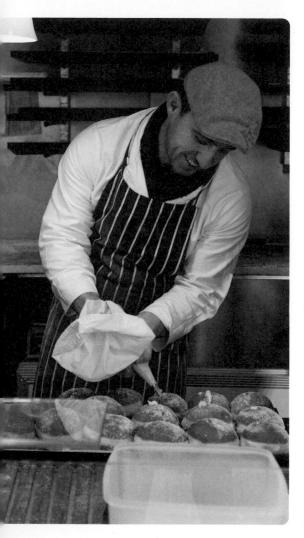

NORTHCOTE ROAD MARKET Northcote Rd, SW11 1PA 🕿 8871 6377 www.northcoteroad.london 8am-6pm Mon-Sun

This outdoor market really gets going on Fridays and Saturdays when there's a full complement of stalls selling fruit, veg, household goods and bricà-brac. However, some of the best traders are around all week, meaning you can always pick up superb loaves, pizzas and doughnuts at Breadstall, or fresh seafood at South Coast Fisheries.

QT TOYS 90 Northcote Rd, SW11 6QN 7223 8637

www.qttoyslondon.com

9.30am-5.30pm Mon-Sat; 9.30am-5pm Sun Toys have been sold at this beloved children's store since 1983, which is no mean feat when you consider its competing with the keen pricing of online retail giants. Its success is perhaps down to its 'something for everybody' approach. This is where you'll find a wooden railway, rubber farm animals and classic jokes alongside the more contemporary Airfix kits, remote-controlled cars and Paw Patrol toys. HAMISH JOHNSTON 48 Northcote Rd, SW11 1PA 2738 0741 www.hamishjohnston.com 9am-6pm Mon-Sat; 11am-5pm Sun Deli items lining the shelves of this small and handsome cheese shop include fancy condiments, divine olive oil, beer by microbreweries, artisanal vermouths and sourdough loaves. Founded in 1994, Hamish Johnston's wholesale business is based in Suffolk, and fresh produce (such as British apples) is often on offer. There's also cheese, lots of delicious cheese.

Ø VERDE LONDON

113 Northcote Rd (via Wakehurst Rd), SW11 6PW

T223 2095
 www.verde.co.uk
 10.30am-5.30pm Tue-Sat; 11am-4pm Sun
 Essential oils and botanicals are the key
 ingredients in this shop's natural and organic
 range of beauty and wellness products. Its
 creams, shampoos and bath salts – as well
 as remedies for specific ailments – all
 smell divine, and knowledgeable staff are
 exceptionally helpful.

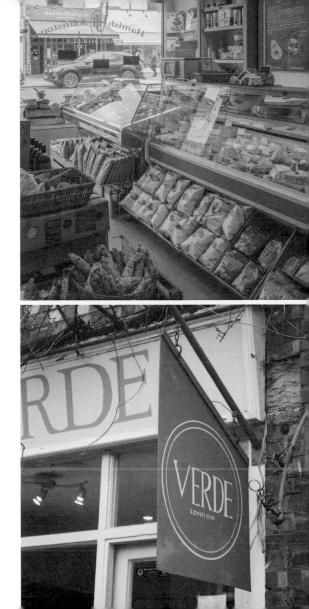

10am-5.30pm Mon-Sat; noon-5pm Sun Some 30 dealers cover a variety of homeware periods and styles in this indoor antique emporium – you'll find casual visitors cooing over retro curiosities, and collectors making investments in silver, china and furniture.

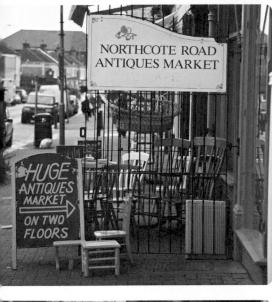

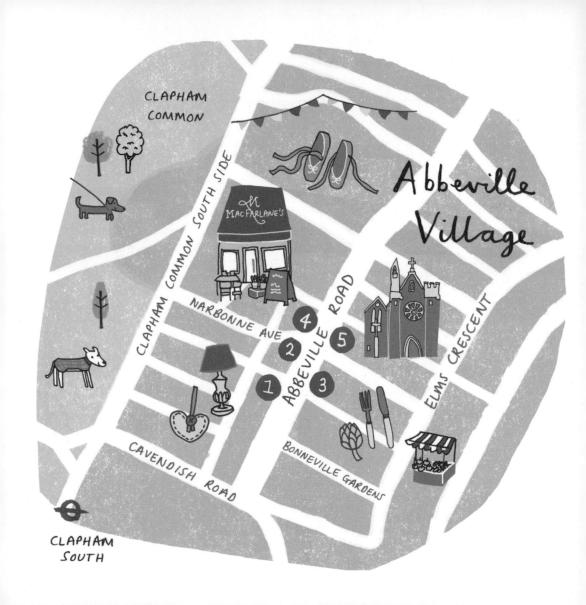

Abbeville Village

This short Victorian shopping parade on Abbeville Road cemented its community character in the late 1990s when it began to be referred to as Abbeville Village. Since then, local house prices have shot up and the road's amenities have become a muddle of chichi boutiques, bistros and estate agents. A couple of overly familiar high street chains have crept in, but by and large the village has maintained its picturesque, period feel – it's also remained a relatively local secret, relying on its detached location (away from Clapham's more wellknown shopping districts and main roads) to protect its peaceful personality. The eastern side of Clapham Common flanks Abbeville Road, and a few dog walkers and pram-pushers find themselves sauntering over to this neighbourhood for events and markets organised by sociable residents. The street comes together for a June fête each summer, and there's a sizeable Christmas fair come winter. During the rest of the year, the local church on Narbonne Avenue is a great hub, hosting a book club and community events.

ABBEVILLE VILLAGE

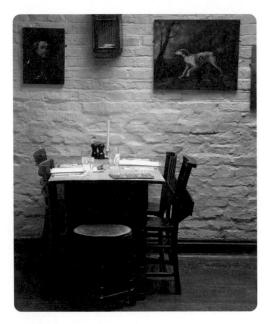

THE ABBEVILLE

67–69 Abbeville Rd, SW4 9JW 28675 2201
www.theabbeville.co.uk 11am-11pm Mon-Thu; 10am-midnight Sat; 10am-10.30pm Sun

Three locals addressed a need for a village hangout in 2002 with this smart and distinctly pastoral pub and dining room. The seasonal menu makes use of animals reared through the pub's own breeding programmes set up in conjunction with small British farms. The chefs also pride themselves on nose-to-tail cooking. ▲ LAVINGIA BEAUTY SPA 51 Abbeville Rd, SW4 9JX ■ 8675 7700 www.lavingiabeauty.com 10am-5pm Mon, Sat; 10am-7pm Tue-Wed, Fri; 10am-8pm Thu; 11am-5pm Sun Slick, contemporary furnishings and a small garden where you can enjoy a pre-treatment cup of tea will ensure you feel right at home in this little oasis of a beauty spa. Friendly therapists add to the relaxed ambience, and services range from indulgent massages to essential waxing and manicures.

ABBEVILLE VILLAGE

ONUE GROUND 32 Abbeville Rd, SW4 9NG www.nueground.co.uk 7.30am-5pm Mon-Fri; 8am-5pm Sat-Sun This bright, light neighbourhood café has a relaxed, clean-living vibe. Roll up for hearty, healthy dishes for breakfast and lunch, from buckwheat pancakes loaded with pistachio cream and berry compote, to salmon poke and a green burger. There are also 'wellness' lattes and immunityboosting shots. A great pitstop.

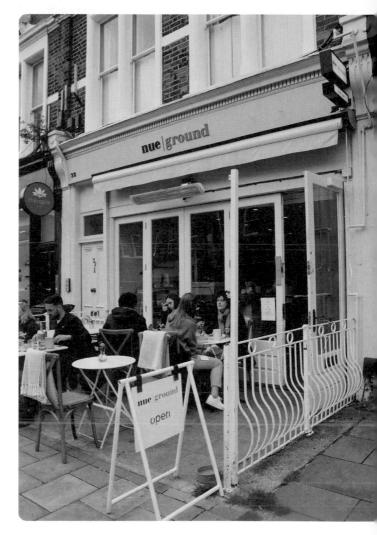

BOTTLE APOSTLE 59 Abbeville Rd, SW4 9JW 3376 1447 www.bottleapostle.com 11am-7pm Mon-Fri; 10am-8pm Sat; 10am-6pm Sun This is a great place to try before you buy: there are always 16 wines to sample via a special enomatic tasting machine. The focus is on taking the mystery out of wine, with really helpful wine descriptions across the shop and loads of information on food pairing. There are two other branches, one in Victoria Park Village (see p139) and another in Crouch End (see p59).

ABBEVILLE VILLAGE

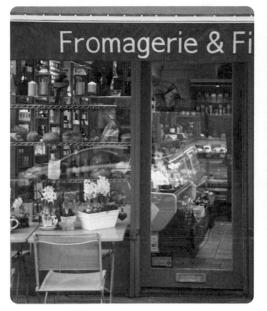

MACFARLANE'S DELI
 48 Abbeville Rd, SW4 9NF 28 8673 5373
 www.macfarlanesdeli.co.uk
 9am-7pm Mon-Fri; 9am-6pm Sat;
 9am-5pm Sun
 Robert Marsham, formerly co-head of

hospitality at Fortnum & Mason, runs this deli with knowledge and care. His first-grade selection of international cheeses, meats, wines and fine foods are meticulously sourced, and the deli's own-made sausage rolls have earned legendary status.

- WHITECROSS VILLAGE 122 COLUMBIA ROAD • 128 BROADWAY MARKET • 134 VICTORIA PARK VILLAGE • 138
 - SHOREDITCH VILLAGE 144

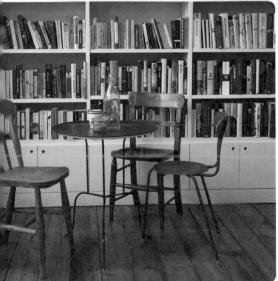

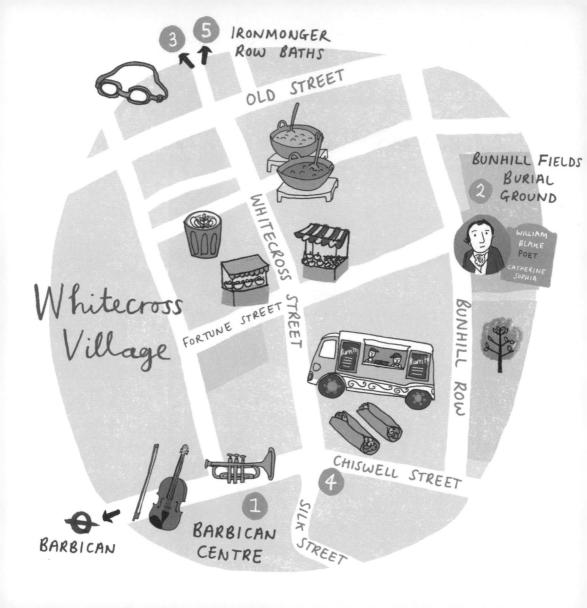

Whitecross Village

Though technically sporting a central London postcode, Whitecross Village is just striking distance from Shoreditch in the east, and best explored together with other villages in this chapter. Try to arrive at lunch, as its main calling card is the weekday food market which brings Whitecross Street roaring to life from around midday. City workers, nearby residents and local shopkeepers descend on the area to buy fresh burritos, curries, bagels, falafels, pies and more. If you are heading over for lunch, make a note of Fortune Street Park at the bottom end of the road, where an abundance of benches provide mealtime seating. Or else head to the Two Brewers at 121 Whitecross Street – a pub that invites you to bring your boxed-up takeaway inside to enjoy with a pint. You can always round off with a visit to Fix at number 161, where baristas use seasonal coffee blends. Aside from foodie nourishment, the road also provides an easy thoroughfare between the Barbican Centre in the south, and chamber-music venue London Symphony Orchestra St Luke's in the north.

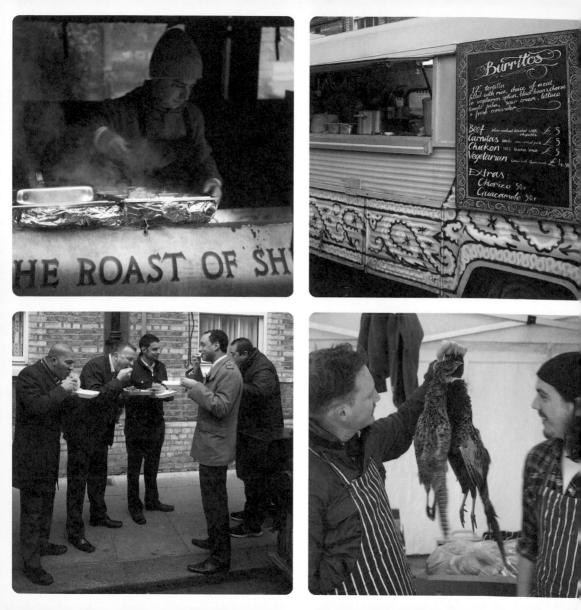

WHITECROSS VILLAGE

The Brutalist architecture of this mammoth building rears up above Whitecross Village. More than a decade in the making, it was opened in 1982 and remains one of the largest arts centres in Europe, curating a cutting-edge programme of music, theatre, dance, art and film.

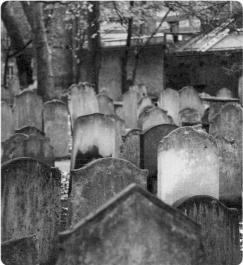

 BUNHILL FIELDS BURIAL GROUND 38 City Rd, EC1Y 2BG
 7374 4127
 www.cityoflondon.gov.uk
 8am-dusk Mon-Fri; 9.30am-dusk Sat-Sun Some 120,000 nonconformists, radicals and dissenters found a final resting place at the Grade I-listed Bunhill Fields. Though the cemetery closed to new burials in the mid-1850s, leftwing sympathisers continue to leave fresh flowers by the stones of William Blake, Daniel Defoe and John Bunyan, and enjoy the peaceful greenery of the adjacent gardens.

WHITECROSS VILLAGE

MODERN ART

4–8 Helmet Row, EC1V 3QJ 7299 7950 Www.modernart.net Noon-5pm Wed-Sat Supporting emerging and established contemporary artists from around the world, Modern Art has a rolling schedule of excellent shows. On its artist and exhibition roster, you'll find Eleonore Koch and Richard Tuttle, as well as Peter Halley and Jacqueline Humphries.

THE JUGGED HARE

49 Chiswell St, EC1Y 4SA ☎ 8161 0190 www.thejuggedhare.com 11am-11pm Mon-Sun

A good place for a drink on your way into or out of the Barbican Centre. A laidback bar at the front makes way for a gastropub-style dining room that's for those with specific tastes: the menu is all about game, starring jugged hare, Yorkshire rabbit loin and haunch of wild roe deer.

 IRONMONGER ROW BATHS
 Norman St, EC1V 3AA
 3642 5520 Www.better.org.uk
 6.30am-9.30pm Mon-Fri; 9am-6pm Sat-Sun Don't let the state-of-the art swimming pool, gym and Turkish spa fool you: these public baths have been at the heart of the local community since 1931. The building underwent a major renovation in 2012, and is now a sparkling blend of heritage and modernity.

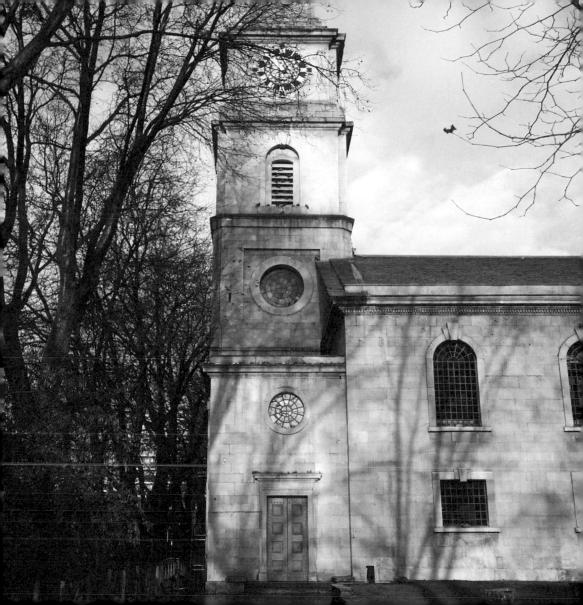

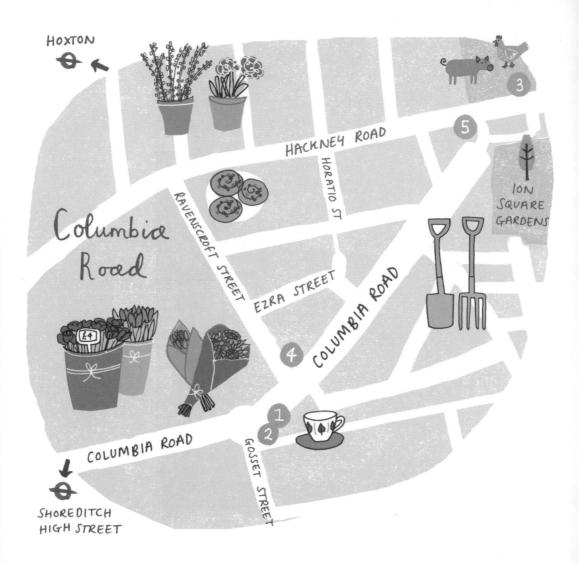

Columbia Road

Best known for its Sunday flower market, Columbia Road is a decidedly weekend destination. Vendors start setting up in the early hours, and keen shoppers arrive at 8am to snap up the freshest cut stems and pot plants, and stock up on gardening equipment, seeds and sundries. By the market's close at 2pm, the vocal flower sellers are swiftly shifting bunches of blooms at bargain prices, and the masses of people streaming between stalls are beginning to thin. The bustling atmosphere remains all day, however, and the dinky shops and cafés

lining the road are usually heaving uncomfortably on Sundays. If you don't fancy battling through on market day, your best bet is to visit on Saturday, when many of the shops are open. Top draws include the fragrant Angela Flanders at number 96 (an independent perfumery that has been concocting intoxicating scents since 1985), as well as Choosing Keeping at number 128, where an array of stylish stationery items is on offer. For an afternoon snack, try Lily Vanilli's in the courtyard off Ezra Street – the adventurous baker turns out fanciful creations, from cherry bakewell pies to a divine pomegranate and coconut sponge.

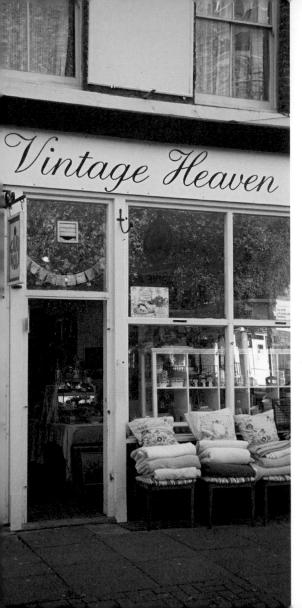

VINTAGE HEAVEN & CAKEHOLE 82 Columbia Rd, E2 7QB www.vintageheaven.co.uk Noon-6pm Sat; 8.30am-5pm Sun Every surface and space of this family-run vintage store is piled high with antique china, Art Deco glassware, fancy cutlery and table linen. At the back, the cute Cakehole café serves homemade bakes and pots of tea.

 BIRDCAGE
 80 Columbia Rd, E2 7QB
 7739 5509
 www.brewdog.com
 Noon-11pm Mon-Wed; noon-midnight Thu; noon-1am Fri-Sat; 9am-10.30pm Sun
 Now owned by BrewDog, Birdcage has long been a destination for craft beer lovers and locals. These days, the handsome Victorian pub has been brought up to date with a lively atmosphere, good music and a classic pub food menu, but it retains some of its original charm.

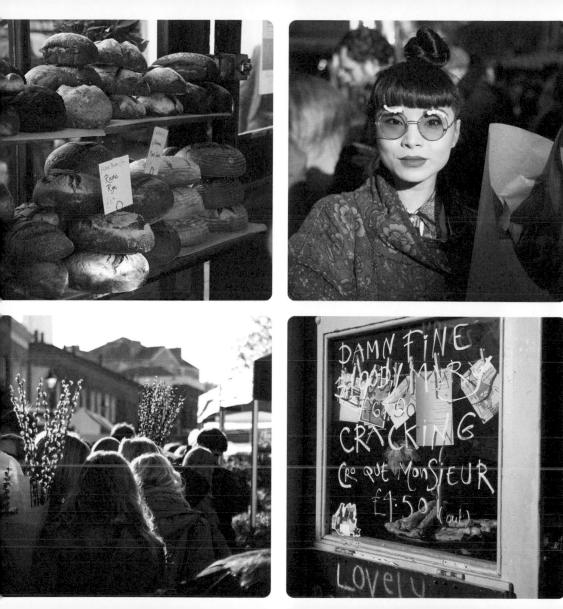

HACKNEY CITY FARM 1a Goldsmiths Row, E2 8QA 7729 6381 www.hackneycityfarm.co.uk 10am-4.30pm Tue-Sun Urbanites can get acquainted with a host of farmyard animals, from donkeys and pigs to rabbits and guinea pigs, at this ramshackle, longrunning city farm. The on-site, award-winning café is the perfect post-petting destination.

BRAWN 49 Columbia Rd, E2 7RG 7729 5692 ... www.brawn.co Lunch noon-2.30pm Wed-Sat; dinner 6pm-10.30pm Tue-Sat An informal, canteen-style setting meets a bold but always successful seasonal menu at this much-lauded restaurant. The natural wine list is one to get stuck into.

5 GRACE AND THORN 312 Hackney Rd, E2 7SJ 🕿 7739 1521

www.graceandthorn.com Seasonal hours vary, but generally open from 9am Mon-Sun Expect floristry with a wild twist here. Among the characterful bouquets, there's a selection of houseplants and dried flowers, as well as a good lifestyle range that includes chic vases, pots and other homeware.

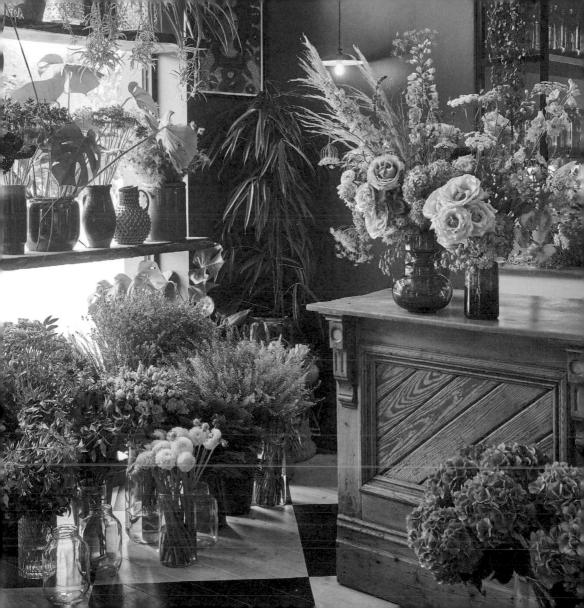

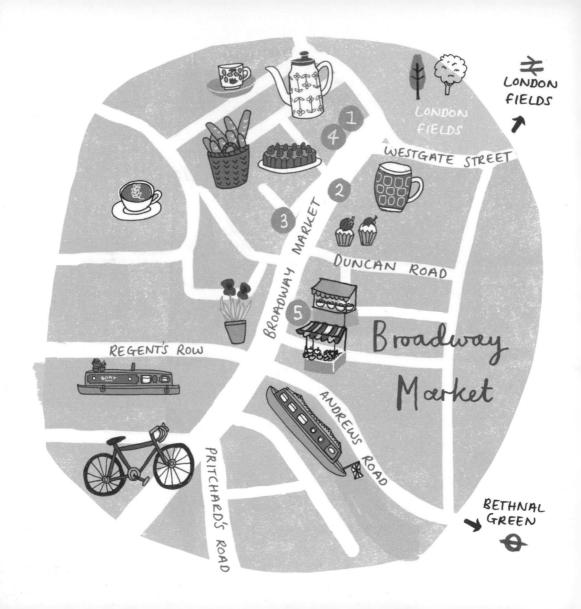

Broadway Market

With Regent's Canal at one end and London Fields at the other, Broadway Market is bookended by two of the East End's most popular alfresco destinations. The canal is a favourite with runners and cyclists, and a couple of moored barges open as book and bric-à-brac shops at the weekend. London Fields, mcanwhile, encompasses a lido (originally opened in 1932 and restored in 2006), a playground and a snug pub. The market itself was established on a drovers' route to the City in the 1890s, but having fallen into decline in the 1980s, it was reintroduced by a troupe of proactive locals in the mid-noughties, rejuvenating the whole area in the process. Today, its food stalls pull in hordes of punters each Saturday, supporting the independent businesses that have popped up along the street. Look out for fishmongers Fin & Flounder, as well as a couple of excellent bookshops, quaint fabric and haberdashery stores and sustenance stops including coffee favourite Climpson & Sons. Among these services, you'll spy a few gentle reminders of Broadway Market's past, such as The Cat & Mutton at number 76 - a boozer which has been serving since the late 1600s.

BROADWAY MARKET

 STELLA BLUNT
 75 Broadway Market, E8 4PH
 07958 716 916
 12.30pm-6pm Wed-Fri;
 10.30am-6pm Sat; noon-5pm Sun
 Manoeuvre carefully through this tightly packed, two-floor store to avoid knocking into a host of immaculate kitsch crockery, reclaimed school chairs, Formica tables and thoughtfully chosen vintage curiosities.

BROADWAY MARKET Broadway Market, E8 4PH www.broadwaymarket.co.uk 9am-5pm Sat

Join the locals to explore the stalls stocked with fresh produce, hot food, cakes, craft and fashion from around 100 sellers. At the top of the road, the smaller Netil Market (13–23 Westgate St, E8 3RL; 11am-6pm Sat) covers vintage threads, jewellery, homeware and still more food.

L'EAU À LA BOUCHE
 35–37 Broadway Market, E8 4PH
 7923 0600
 www.labouche.co.uk
 8am-7pm Mon-Fri; 8.30am-5pm Sat;
 9am-5pm Sun
 This wonderfully fragrant French food store and deli makes room for a giant (and always busy)

136

BROADWAY MARKET

communal table, where diners munch on fresh salads, quiches and cakes. There's wine on barrel tap (with a good-value carafe refill service), artisan cheese, store-cupboard treats and lovely farm produce.

🚱 69B BOUTIQUE

69b Broadway Market, E8 4PH 7682 0506
www.69bboutique.com 10.30am-6.30pm Mon-Fri; 10am-6pm Sat; 11am-6pm Sun

Shop with a light conscience at this socially and environmentally ethical boutique which makes the effort to source only the most transparent of labels. Browse racks for pieces by Marimekko and People Tree as well as a raft of indies and up-and-comers.

9 PAVILION BAKERY

18 Broadway Market, E8 4QJ www.pavilionbakery.com 7.30am-4pm Mon-Fri; 7.30am-5pm Sat-Sun Columbia Road (see p129) and Victoria Park have their own outposts of this excellent bakery. This Pavilion is small, with a focus on takeaway loaves, coffees, sandwiches and pastries. Whatever you go for, it'll be heavenly.

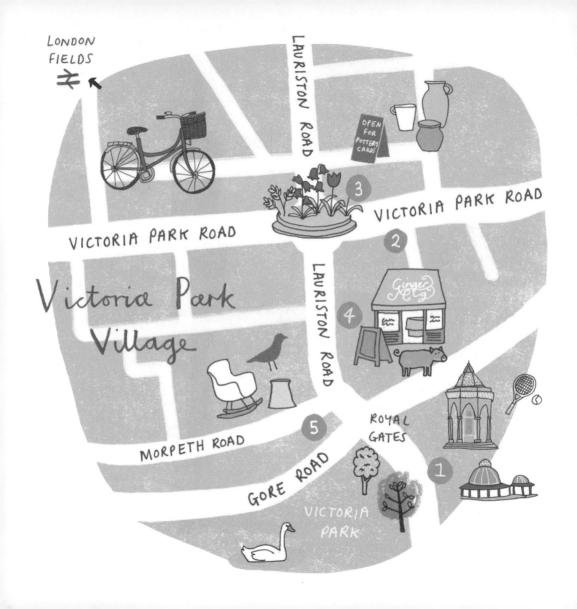

Victoria Park Village

Bordering the northwestern edge of Victoria Park, and at least half a mile from the nearest train station, this self-contained pocket of Hackney feels like a village plucked straight out of the British countryside. Its four main streets radiate outward from a central roundabout, which was transformed from a weed-ridden eyesore into a blooming, award-winning plot by resident gardener Caroline Bousfield. Her handiwork has given the village a much-loved centrepiece – but it isn't the only local award-winner. Wine shop Bottle Apostle and butchers The Ginger Pig have both won sought-after industry gongs, while gastropub The Empress has been decorated with a Michelin Bib Gourmand.

These destinations can be found alongside worthy neighbours, including fishmonger Jonathan Norris and the bustling Deli Downstairs, and a number of pubs and restaurants. Tea and cake come via the homely Loafing, and stonebaked pizza, a pint and a bit of live music are supplied at The Lauriston.

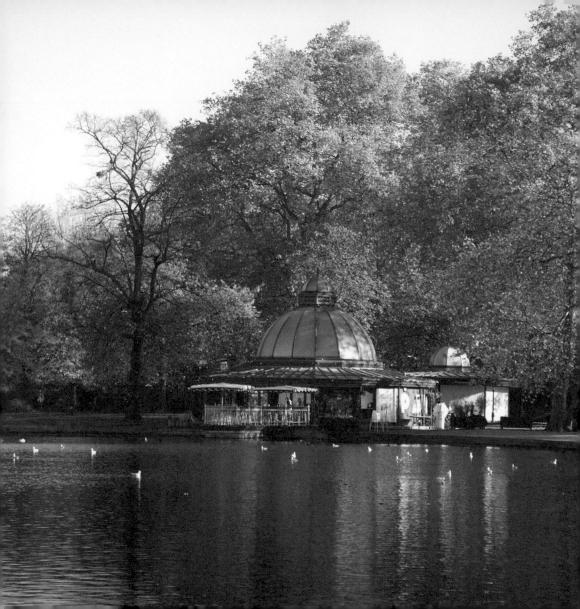

VICTORIA PARK VILLAGE

VICTORIA PARK

Best accessed via the Crown and Royal Gates on Grove Rd www.towerhamlets.gov.uk 7am-dusk Mon-Sun

Overcrowded and polluted, the nineteenthcentury East End was in dire need of green and open space. Queen Victoria backed plans for a pleasure garden, and Victoria Park (dubbed The People's Park) was developed in the 1840s. Over the decades its glamour faded, but a much-required facelift in 2012 returned the park, monuments and boating lake to their former glory.

MY NEIGHBOURS THE DUMPLINGS

178–180 Victoria Park Rd, E9 7HD 2327 0447

www.myneighboursthedumplings.com 5pm-10pm Tue; noon-4pm & 5pm-10pm Wed-Fri; noon-10pm Sat; noon-9pm Sun Dumplings are freshly rolled and folded at this modern, family-run Chinese restaurant. It's the sister dumpling house to the Lower Clapton Road original, and the dim sum and sake (which comes straight from small producers in Japan) is every bit as delicious.

THE TOYBOX 223 Victoria Park Rd, E9 7HD 8533 2879

www.thetoyboxshop.co.uk 9am-6pm Mon-Sat; 10am-5pm Sun You'll have a hard time tearing the kids away from this fun-loving and colourful toy store, which is packed full of cuddly creatures, board games, fancy dress costumes and more. The focus here is on real, practical toys rather than trendy, expensive pieces, and children of all ages are well catered for, from tots to pre-teens.

VICTORIA PARK VILLAGE

THE GINGER PIG 99 Lauriston Rd, E9 7HJ ☎ 3869 7830 www.thegingerpig.co.uk 9am-5pm Mon-Sat

Handsome cooked meat pies eye you from the window of this legendary butcher shop. Its cuts of pork, beef and lamb are from animals reared free-range on the Yorkshire Moors, other meats are sourced responsibly, and the pies, pâtés and chutneys are all handmade.

6 HAUS

39 Morpeth Rd, E9 7LD ☎ 8533 8024 www.hauslondon.com 11am-6pm Mon-Sat; 11am-5pm Sun Andrew and Jane Tye have filled their sleek store with a tasteful edit of contemporary design pieces for the home. Scandi-style furniture and creative lighting, kitchenware and gifts are sourced from international brands and indie designers.

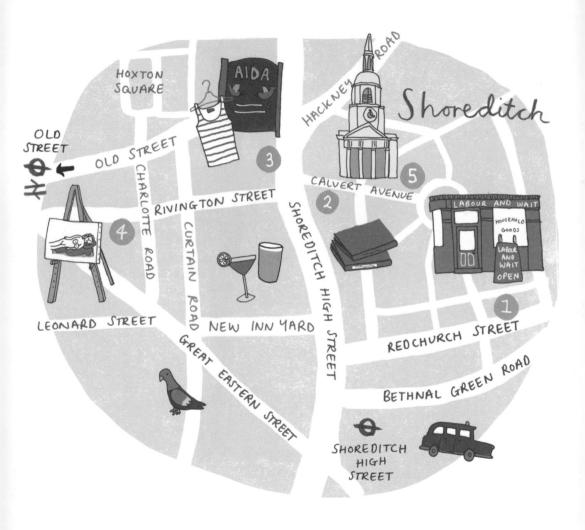

Shoreditch Village

Often described as London's creative hub, Shoreditch has seen a stream of big chain establishments trickle in over the last few years, diluting the area's once boho appeal and driving out some of the artists who sparked its gentrification in the late 1990s. Despite this, an ever-burgeoning number of genuinely independent and imaginative retailers continue to maintain Shoreditch's villagey feel, and the streets entangled around Shoreditch High Street, Curtain Road and Great Eastern Street accommodate a hodgepodge of cult boutiques, vintage stores and bars. 'Ihe area's heritage, however, ensures it's more than just a nightlife spot: Shoreditch Town Hall adds Victorian grandeur on Old Street, while the Church of St Leonard has been open for prayer since 1740. Its grounds have actually been a place of worship since the twelfth century; it was used as an actors' church in the 1500s and is also the resting place of James Burbage. An apt fact, given that the Elizabethan impresario built a playhouse (among the first in England) across the street where New Inn Yard meets Curtain Road.

LABOUR AND WAIT
 85 Redchurch St, E2 7DJ
 7729 6253
 www.labourandwait.co.uk
 11am-6pm Tue-Sun
 A traditional hardware store with
 a fashionable twist, Labour and
 Wait has nostalgic, functional
 design down pat. Enamel jugs,
 wooden cleaning brushes, steel
 buckets and stylish screwdrivers
 should inspire you to inject a little
 chic into household chores.

SHOREDITCH VILLAGE

2 PAPER & CUP

AIDA 133 Shoreditch High St, E1 6JE 7739 2811 www.aidashoreditch.co.uk 11am-6pm Mon-Sat; 11am-5pm Sun A really well-curated store where you can browse rails of indie fashion labels at fairly accessible prices. There's space for both men's and women's apparel (plus shoes and a few lifestyle pieces), as well as a small café facing Shoreditch High Street.

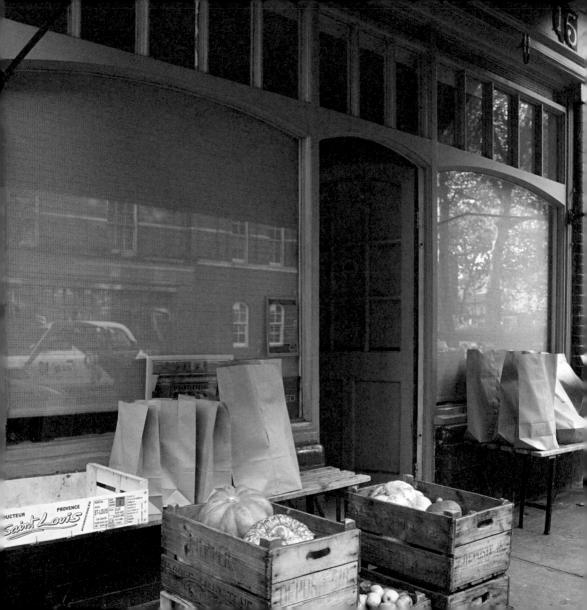

SHOREDITCH VILLAGE

THE ROYAL DRAWING SCHOOL 19–22 Charlotte Rd, EC2A 3SG 7613 8568

www.royaldrawingschool.org Founded by the Prince of Wales and artist Catherine Goodman in 2000 to champion the discipline of drawing, this school runs a public programme of daytime and evening drawing courses for adults and children, both online and in the studios. There's also a ground-floor gallery that often exhibits students' work.

6 LEILA'S SHOP

15–17 Calvert Ave, E2 7JP www.leilasshop.co.uk Shop: noon-4pm Tue-Fri; 10am-4pm Sat Cafe: noon-3pm Wed-Sat A café and grocer's shop where you can stock up on British-grown fruit and veg, gorgeous cheeses from the UK and Europe, and breads and biscuits made on the day. The café does a simple menu that draws on the fresh produce it sells, so expect it to be brief but delicious.

West

QUEEN'S PARK • 152 TURNHAM GREEN • 158 BARNES VILLAGE • 164 LITTLE VENICE • 168 GOLBORNE ROAD • 174 CLARENDON CROSS • 180

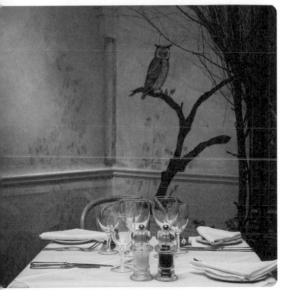

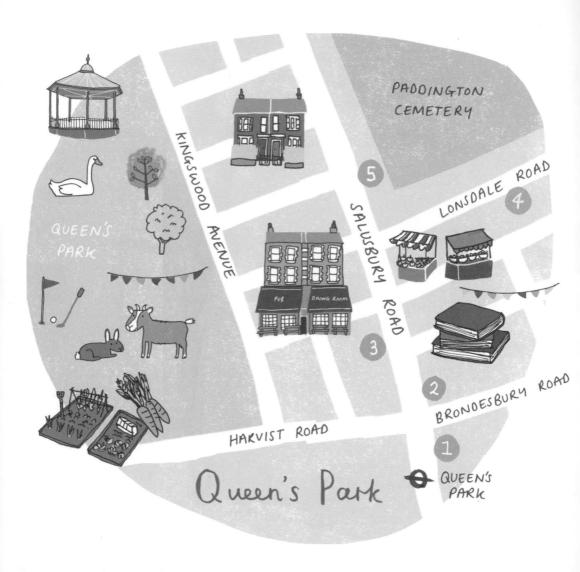

Queen's Park

Queen's Park grew furiously in the late nineteenth century: terraces sprung up to house the working classes, and its eponymous centrepiece – a 30-acre park designed in a figure of eight – was unveiled in honour of Queen Victoria's Golden Jubilee. The park quickly became the heart of the village, morphing with the changing needs of residents: a grandstand was installed in 1891, tennis courts in the 1930s, allotments during WWII and an animal petting corner in the 1990s. It continues to be well used and is celebrated each September on Queen's Park Day when village businesses set up stalls and local groups put on a show. The family festival is just one of the events organised by the voluntary Queen's Park Residents' Association, and joins the annual Open Gardens and Studios day in June and the Book Festival in May. Queen's Park Books on Salusbury Road has an integral role in the latter, encouraging celebrity and local authors to helm readings, talks and signings, while the neighbouring library and local schools get involved with children's events and workshops.

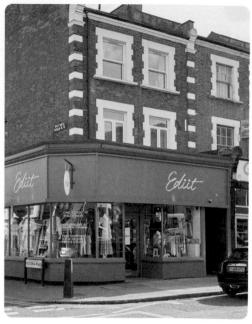

 MR FISH
 51 Salusbury Rd, NW6 6NJ
 7624 8181 Www.mrfish.uk.com
 11.30am-midnight Mon-Sun
 A local chippy with a London-wide reputation, Mr Fish looks like it's been transposed from a
 British seaside town. Its retro décor is matched by a nostalgic menu (there's prawn cocktail to start and sponge pudding to finish), though the main draw is its battered fish and light, crisp chips.

2 EDIIT

73 Salusbury Rd, NW6 6NJ

T372 7390 Www.ediitstore.com 9.30am-6pm Mon-Sat; 10am-4pm Sun Providing stylish villagers with high-end fashion, Ediit stocks a discerning mix of labels from Libby Loves to By Malina. It's always evolving and has a small but good range of accessories and smart gifts, such as candles and luxury eye masks.

THE SALUSBURY 50–52 Salusbury Rd, NW6 6NN 7328 3286 www.thesalusbury.co.uk 4pm-11pm Mon-Thu; noon-midnight Fri-Sat; noon-11pm Sun

This bar and dining room has won a legion of fans with its convincing Italian menu and cosy pub interior, and it takes pride of place among three jointly owned and adjacent businesses that bear the name Salusbury. Pop next door for the Salusbury Winestore (where you can try wines by the glass), or head two doors down for the fashionable Salusbury Deli.

MILK BEACH

QUEEN'S PARK FARMERS' MARKET

Salusbury Road Primary School, Salusbury Rd, NW6 6RG 📓 www.lfm.org.uk 10am-2pm Sun

Queen's Park residents flock to this awardwinning market each Sunday, so be prepared to sidestep regulars gassing with friends if you want to cover some 30 stalls selling free-range and organic groceries fresh from nearby farms, as well as more unusual products such as oaksmoked garlic.

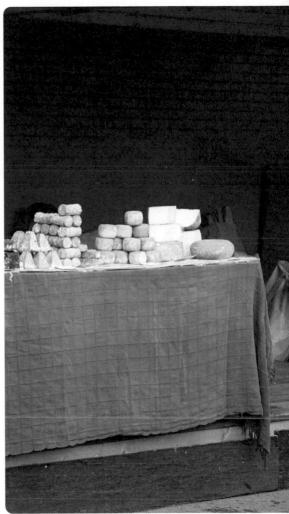

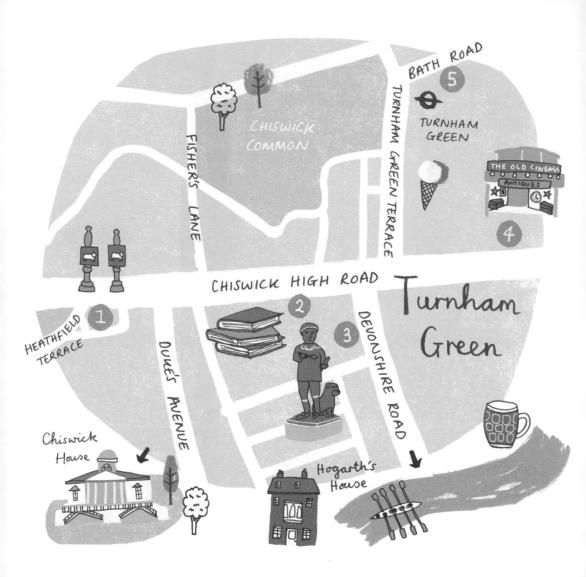

Turnham Green

Though situated a little north of Chiswick's main attractions, Turnham Green has established itself as the commercial heart of the area. To its south runs an incredibly scenic stretch of the Thames dotted with rowing clubs and pubs. Inland, Palladian villa Chiswick House attracts vast numbers of tourists, as does Hogarth's House – the former country pad of Georgian artist William Hogarth.

For Londoners, the rather upmarket Chiswick car boot sale operates on the first Sunday of every month from the school on Burlington Lane, and the area's centuries-old brewing heritage means there are plenty of historic pubs to enjoy. 'Ihere's little to get excited about along Chiswick High Road itself, dwarfed as it is by high street restaurants and chains, but offshoots Turnham Green Terrace and Devonshire Road lay claim to a stronghold of independent retailers. On Turnham Green Terrace, a number of delis have made the street a destination for fans of fine food, and Foubert's Café (a local institution since 1980) is famous for its Italian ice cream. Devonshire Road, meanwhile, offers clothes boutiques, gift shops and the ramshackle Strand Antiques at number 46.

THE LAMB 9 Barley Mow Passage, W4 4PH 8994 1880 www.thelambchiswick.co.uk Noon-11pm Mon-Sat; noon-10pm Sun This bar and dining room opened in 2012 in honour of the original Lamb Brewery that operated around the corner between 1790 and 1922. It launched with its own micro-brewery, but now serves up craft beers and ales by a range of other small and indie

serves up craft beers and ales by a range of other small and indie brewers. In contrast, you can take a tour of the nearby Fuller's Griffin Brewery, which is London's biggest independent beer maker.

TURNHAM GREEN

OF FOSTER BOOKS

183 Chiswick High Rd, W4 2DR 8995 2768 www.fosterbooks.co.uk 10.30am-5.30pm Mon-Sat

The Foster family has run this tightly packed antiquarian store since 1968 and continues to acquire and sell a choice selection of rare books and first editions, together with volumes of local history and more general Penguin paperbacks and illustrated children's novels.

🚯 LA TROMPETTE

3–7 Devonshire Rd, W4 2EU 🖀 8747 1836 www.latrompette.co.uk Noon-2pm Wed-Sat; noon-3pm Sun; 6pm-9.30pm Wed-Thu; 6pm-10pm Fri-Sat La Trompette's refined décor and sophisticated French menu make it one of Chiswick's most prized neighbourhood restaurants. Owners Nigel Platts-Martin and Bruce Poole are also responsible for Chez Bruce near Wandsworth Common and The Glasshouse in Kew, so it's a safe bet for a decent dining experience.

THE OLD CINEMA 160 Chiswick High Rd, W4 1PR 8995 4166 www.theoldcinema.co.uk 10am-6pm Mon-Sat; 11am-5pm Sun As its name implies, this antiques emporium was once a working picturehouse serving Chiswick locals in the early 1900s. Evidence of the building's original use survives, but the cavernous two-floor showroom is now crammed with attention-stealing homeware, ranging from opulent Art Deco dressers to polished steel factory furniture from the '50s.

CHISWICK PLAYHOUSE

2 Bath Rd, W4 1LW 🖀 8995 6035 www.chiswickplayhouse.co.uk A studio theatre with strong family appeal, this 90-seat fringe venue lives above nineteenthcentury pub The Tabard. It may feel a little humble, but its in-house productions have been known to transfer to the West End and embark on UK tours. It also hosts regular comedy gigs.

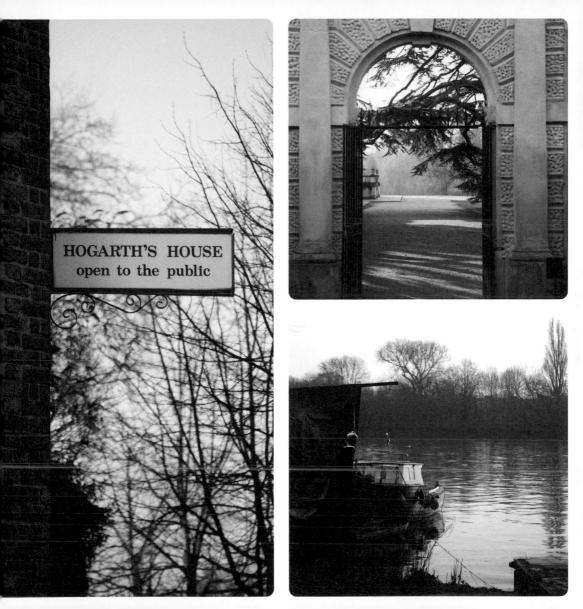

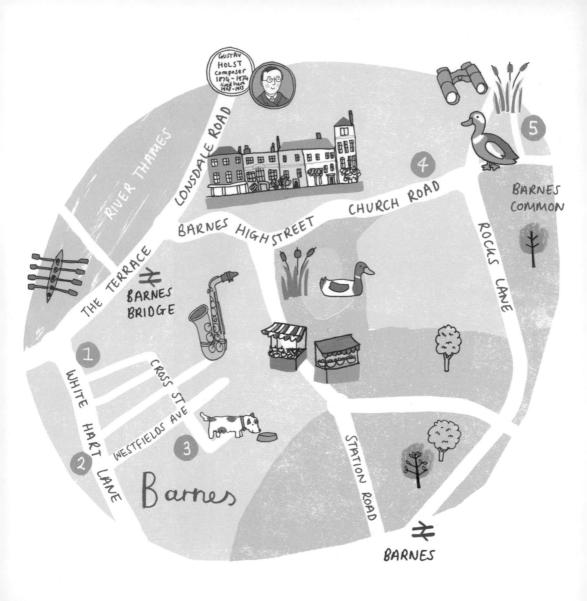

Barnes Village

Of all London's Thameside villages, Barnes is perhaps the most alluring. On any given day you'll see rowers powering down its snaking stretch of river, locals making the most of a scenic promenade and families feeding the ducks at the impossibly picturesque village pond. The Oxford-Cambridge Boat Race in April is a yearly highlight here, though the community's willingness to organise events mean there's always something worth pitching up for. Barnes lays claim to one of the biggest summer fêtes in London, for example, as well as an annual bonfire night and a weekly farmers' market. There's an antiques fair on the first Saturday of every month and nightly live jazz at the legendary music venue-cum-pub The Bull's Head on Lonsdale Road. All this civic activity, coupled with an idyllic setting, keeps demand for houses (and their prices) extremely high. One of the most desirable spots is the riverfacing Terrace where Gustav Holst (composer of The Planets) and Dame Ninette de Valois (founder of The Royal Ballet) once lived. You can spy their Blue Plaques among other sights on the two-kilometre circular Barnes Trail-just follow the metal markers embedded in the pavement.

BARNES VILLAGE

ORANGE PEKOE

3 White Hart Lane, SW13 OPX 8876 6070 www.orangepekoeteas.com 8am-5pm Mon-Fri; 9am-5pm Sat-Sun This bright and airy tea room makes much of its expertly sourced loose-leaf tea stored strikingly in large black tins. An informal afternoon tea includes a blend of your choice, billowing scones and a decent wedge of cake, all served on vintage crockery.

TOBIAS AND THE ANGEL 68 White Hart Lane, SW13 0PZ

☎ 8878 8902

www.tobiasandtheangel.com 10am-6pm Thu-Sat

It's not just the shop cat curled up on the sofa that makes Tobias and the Angel feel like home. Its creaky warren of rooms is furnished like a country house and shows off handcrafted furniture, vintage and new homeware, light shades, linens and hand-block-printed fabrics, which are sold by the metre and used to make cushions, lavender bags and doorstops.

STHE BROWN DOG 28 Cross St, SW13 0AP ☎ 8392 2200 www.thebrowndog.co.uk 5pm-11pm Mon-Wed; noon-11pm Thu-Sat; noon-9pm Sun Barnes Common dog walkers and their canines tend to decamp in this pooch-friendly pub where locally brewed cask ales are available on tap and bowls of water are dotted about on the floor. Ask the staff to snap a Polaroid photo of your pet and they may well add it to the doggy wall of fame.

THE OLYMPIC CINEMA

117–123 Church Rd, SW13 9HL www.olympiccinema.co.uk The Olympic Cinema opened in 2013, taking the place of the Olympic Sound Studios which famously played host to dozens of big names – The Rolling Stones, The Beatles, Queen, The Who and U2 among them – who recorded here over a forty-year period. The boutique cinema now incorporates a chic dining room, café and tuck shop.

LONDON WETLAND CENTRE Queen Elizabeth Walk, SW13 9WT [∞] 8409 4400 [∞] www.wwt.org.uk [∞] 9.30am-5pm Mon-Sun

You'll see plenty of twitchers with flasks tucked under one arm and birdwatching guides under the other in this brilliant 105-acre Wildfowl and Wetlands Trust reserve. As well as a network of walkways and gardens, the centre offers an adventure playground, ponddipping opportunities, an otter holt and guided tours.

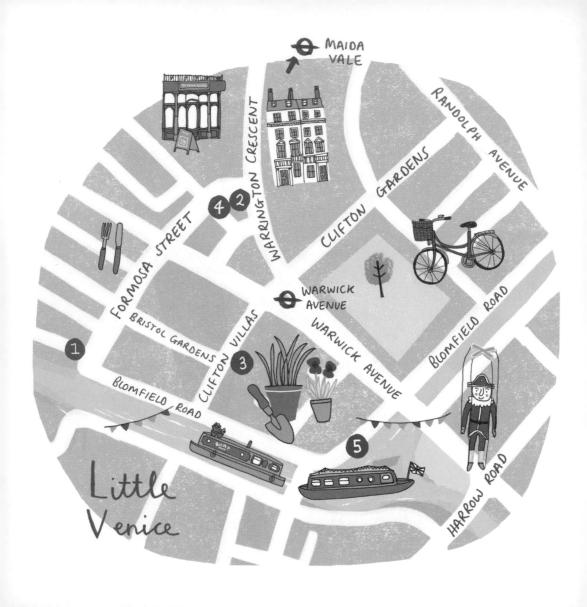

Little Venice

Little Venice – a triangular-shaped pool where the Grand Union Canal and Regent's Canal meet - is at the centre of a serene Paddington locale famous for its moored barges, leafy walkways and waterside pubs. Perversely, the evocatively named village couldn't feel less Italian, particularly when the annual Canalway Cavalcade bobs into town. Established in 1983, the festival sees more than 100 dressed-up boats gather on the water for a summer pageant, while Morris dancers and a real ale bar fuel the fun. At any time of year, however, it's normal to see bemused tourists intrigued by this countrified stretch of the city. To get a better feel for the area, it helps to wander off the waterway and explore Warwick Avenue's well-hidden shops. A small section of Formosa Street is where you can unearth the majority of the retail activity and a number of good local eateries, though there are also a few boutiques along Bristol Gardens. Ramble beyond here and you'll be rewarded with spectacular local architecture which runs along majestic, tree-lined avenues. Make special note of the Italianate, mid-nineteenth-century housing on both Randolph Avenue and Warrington Crescent.

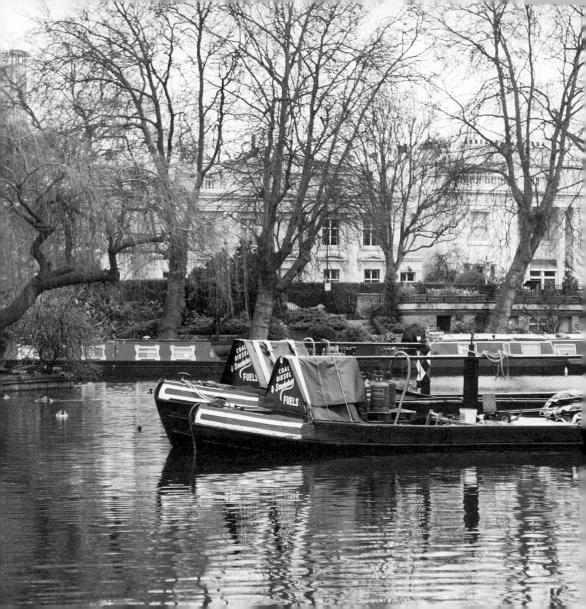

LITTLE VENICE

THE WATERWAY 54 Formosa St, W9 2JU T 7266 3557 www.thewaterway.co.uk 10am-11pm Mon-Sat; 10am-10.30pm Sun The Waterway is fortunate enough to overlook the Grand Union Canal and its chief charm is a spacious outdoor terrace. Despite its alfresco allure, on a sunny day the restaurant-bar is up against stiff competition from the neighbouring Summerhouse (60 Blomfield Rd, W9 2PA), which is even closer to the water's edge.

CLIFTON NURSERIES 5a Clifton Villas, W9 2PH 7289 6851 Www.clifton.co.uk 9am-6pm Mon-Sat; 11am-5pm Sun Sandwiched between two houses on the residential Clifton Villas, this nursery has been incongruously located since 1851. It merits a visit even if you're not a garden owner, as its three interconnected shops stock pretty items

THE PRINCE ALFRED & FORMOSA DINING ROOM 5a Formosa St, W9 1EE 🕿 7286 3287

for the home as well as garden-inspired gifts.

www.theprincealfred.com Noon-11pm Mon-Fri; 10am-11pm Sat; noon-10.30pm Sun

The Prince Alfred's original snug rooms, snob screens and decorative tiles make it one of the best examples of a late Victorian pub in London. The ornate bar is adjoined to the intimate Formosa Dining Room, which enjoys repeated recommendations in Michelin's Eating Out in London guide.

S PUPPET THEATRE BARGE Opposite 35 Blomfield Rd, W9 2PF ☎ 7249 6876 www.puppetbarge.com This floating marionette theatre and local landmark opened back in 1982, and continues to present and tour productions for children and adults. If you don't have your sea legs, stick to dry land at the nearby Canal Café Theatre (Delamere Terrace, W2 6NG) which also programmes plays, comedy and cabaret.

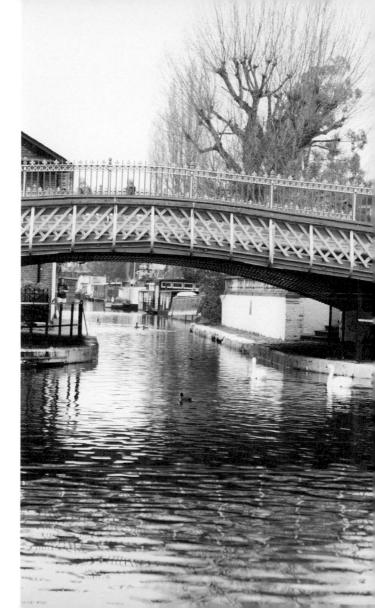

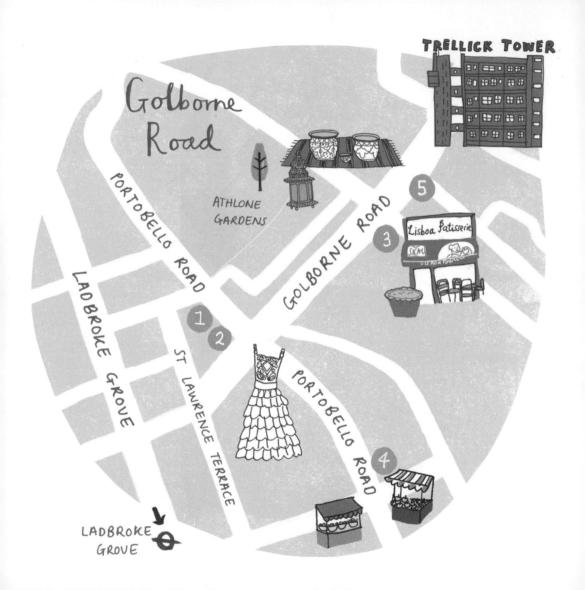

Golborne Road

Tourists often miss out on the delights of Golborne Road, unwittingly sticking to the main stretch of Portobello Road instead. Those who make their way toward the very north of Portobello Road will be rewarded with a more casual shopping experience. Under the shadow of Ernö Goldfinger's infamous, 31-storey Trellick Tower, market sellers arrange their jumble of bric-à-brac across rugs on the pavement, food stalls have space to offer seating, and shops range from secondhand furniture dens to contemporary gift stores. The Moroccan, Lebanese and Portuguese communities here add personality, as people sociably sip coffee in clamorous cafés and families cat freshly grilled fish served by Middle Eastern food vendors. It makes for a dynamic and intimate addition when visiting the more established and sprawling Portobello Road, and the two are best visited together. Both areas share the same market days, with the majority of stalls open on Fridays, Saturdays and Sundays. Some traders work throughout the week, though mainly just the fruit and veg sellers.

GOLBORNE ROAD

\rm LOWRY & BAKER

339 Portobello Rd, W10 5SA 28960 8534
www.lowryandbaker.co.uk 8am-4pm Mon-Fri; 8am-5pm Sat; 8am-4pm Sun

A brunch favourite, this Notting Hill hotspot is a cosy, homey alternative to Golborne Road's stalls. If you're lucky enough to bag a table, get ready to tuck into classics including smoked salmon, avocado and eggs, or sautéed mushrooms on sourdough. Coffee comes via Monmouth and the cake counter is always bountiful and tempting.

GEORGE'S PORTOBELLO FISH BAR

329 Portobello Rd, W10 5SA 28 8969 7895

Noon-8pm Tue-Thu, Sat; noon-9pm Fri George Periccos opened this popular fish and chip shop in 1961 and, though he might not be behind the counter these days, the frying of fresh cod, haddock and plaice is still going strong, all battered to perfection. There's limited seating, so be prepared to take away.

Anyone with a taste for a one-off homeware piece will be transported by this store. It's stuffed with vintage finds, natural history curiosities and striking prints, lighting and furniture. Look out for items such as a life-size Italian ceramic cocker spaniel or a framed (and original) 1970s poster of Mick Jagger. The owner has been buying, selling and loaning items for more than 25 years, so knows a thing or two.

JANE BOURVIS

7 Portobello Green Arcade, 281 Portobello Rd, W10 5TZ 28964 5603
Www.janebourvis.com 11am-6pm Mon-Tue

Walking into this vintage bridal shop feels like wandering into Miss Havisham's dressing room. Dozens of antique lace dresses hang from the ceiling, corsets weigh down rails, and every available surface is topped with trinkets, strings of pearls and wind-up music boxes.

LISBOA PATISSERIE

57 Golborne Rd, W10 5NR 🖀 8968 5242 7.30am-5.30pm Tue-Sat; 8am-5pm Sun

It's hard to believe anyone could find a more heavenly custard tart outside of Portugal than at Lisboa. The patisserie's legendary pastéis de nata are the reason that patient punters stand in line daily, though its palmiers and pão de lietes (milk bread rolls) are equally worth waiting for.

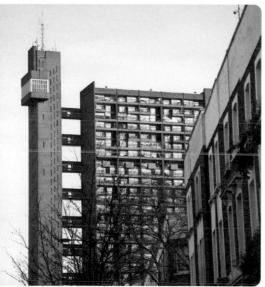

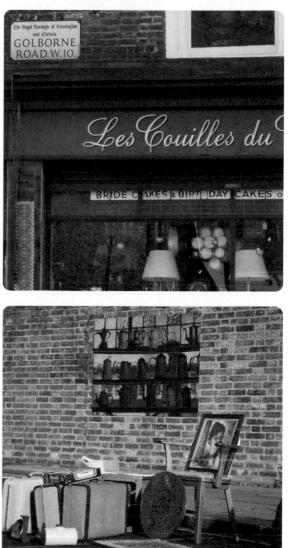

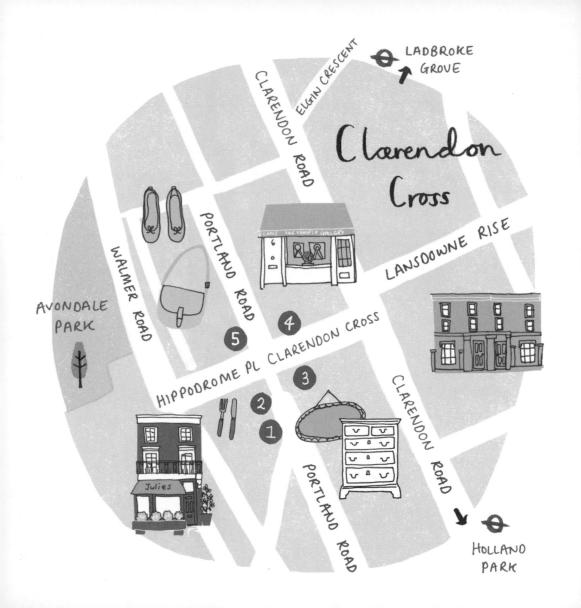

Clarendon Cross

Whether you're arriving at Clarendon Cross from Ladbroke Grove, or strolling up from Holland Park, you'll have the chance to admire rows of pastel-coloured houses lined up like Ladurée macarons in a box. These multimillion-pound properties were once the site of notorious slums known for their population of brick-makers and pig-keepers in the early 1800s and, later, impoverished and immigrant communities. Relics of the 'potteries and piggeries' era remain on Walmer Road where a tile kiln stands adjacent to the entrance of Avondale Park (itself once covered in pig slurry), and longtime residents still remember the area as infamously grotty right into the 1960s. Clarendon Cross itself - a tiny spot with a big reputation – began life as a village of amenities in the early 1900s when there was a dairy and newsagent, a sweetshop and grocers. But the arty middle classes started arriving in the 1970s, and the shops took on a more bohemian character. Gentrification took hold over the next twenty years and Clarendon Cross became a magnet for London's richest looking to raise their families in an attractive central locale. The mini-village is now a go-to destination for upmarket interior designers.

 MYRIAD
 131 Portland Rd, W11 4LW
 7229 1709
 11am-6pm Tue-Sun (or by appointment)
 Sara Fenwick mixes antique finds from international markets with new stock and one-off commissions in this two-floor homeware store. Her style is casual luxury, so expect myriad farmhouse tables, bell jars, mirrors and battered leather armchairs.

JULIE'S 135 Portland Rd, W11 4LW 7229 8331 www.juliesrestaurant.com 10am-11pm Tue-Sat When it opened in 1969, Julie's arguably put the then down-at-heel Clarendon Cross on the map. A-list actors, fashion royalty and rock 'n' roll legends once flocked here, and you might still see the odd star in one of the restaurant's many intimate, shabby-chic alcoves.

CLARENDON CROSS

SUMMERILL & BISHOP 100 Portland Rd, W11 4LQ ☎ 7221 4566 www.summerillandbishop.com 10am-6pm Mon-Sat

If you lust after the rustic charm of a Provençal kitchen, there's plenty to fall for here. Earthy linens, farmhouse crockery, wooden dusters, vintage glassware and handmade bowls come together alongside useful equipment to make this one of London's best kitchen shops.

CLARENDON CROSS

S THE CROSS 141 Portland Rd, W11 4LR ☎ 7727 6760 www.thecrossshop.com 11am-5pm Mon-Sat

The Cross was one of the first of its kind in London: a lifestyle boutique covering an inspiring blend of independent fashion labels, children's clothes, toys, gifts, accessories and jewellery. Every surface and rack of the shop's two floors is stuffed, making this a happily time-consuming place to visit.

Index

VILLAGES

Abbeville Village 114 Barnes Village 164 Bellenden Road 92 Bermondsey Street 38 Brixton Village 98 Broadway Market 134 Camden Passage 68 Chelsea Green 102 Clarendon Cross 180 Columbia Road 128 Connaught Village 22 Crouch End 58 East Bloomsbury 28 East Dulwich 86 Exmouth Market 32 Golborne Road 174 Hampstead Village 78 Highgate Village 62 Little Venice 168 Lower Belgravia 44 Marylebone Village 10 Northcote Road 108 Primrose Hill 52 Oueen's Park 152 Shepherd Market 16 Shoreditch Village 144 Stoke Newington Church Street 74 Turnham Green 158 Victoria Park Village 138 Whitecross Village 122

BARS, PUBS & GASTROPUBS

5 Hertford Street 17 Abbeville, The 116 Birdcage 130

Brown Dog, The 167 Bull's Head, The 165 Cat & Mutton. The 135 Chesterfield Arms, The 20 Empress, The 139 Flask, The (Hampstead) 82 Flask, The (Highgate) 63 Garrison, The 39 Jolly Butchers, The 75 Jugged Hare, The 126 Lamb, The (Bloomsbury) 29 Lamb, The (Chiswick) 160 Lauriston. The 139 Montpelier, The 93 Pembroke Castle, The 53 Prince Alfred & Formosa Dining Room, The 172 Oueens, The 60 Salusbury, The 155 Thomas Cubitt. The 47 Three Crowns, The 75 Two Brewers 123 Victoria Inn, The 93 Waterway, The 171 Woolpack, The 39 Ye Grapes 20

CAFÉS & RESTAURANTS

Begging Bowl, The 96 Blue BrIck Café 89 Blue Mountain Vegan 87 Brawn 132 Breakfast Club, The 69 Cakehole 130 Caravan 35 Casse-Croûte 42 Climpson & Sons 135

.....

Coffee Circus 60 Espresso Room, The 29 Federation Coffee 101 Fix 123 Foubert's Café 159 Franco Manca 101 Franklins 90 George's Portobello Fish Bar 177 Good Egg, The 75 losé 39 Iulie's 183 Kipferl 72 Kitty Fisher's 19 La Trompette 161 L'eau à la Bouche 136 Le Boudin Blanc 20 Le Brixton Deli 99 Leila's Shop 149 Lily Vanilli's 129 Lisboa Patisserie 178 Loafing 139 Lowry & Baker 177 Melange Chocolate Shop & Café 96 Milk Beach 156 Moro 33 Mr Fish 154 My Neighbours the Dumplings 142 Noble Rot 31 Nue Ground 117 Orange Pekoe 167 Paper & Cup 147 Pavilion Bakery 137 Peggy Porschen 48 Pizarro 39 Primrose Bakery 57 **Redemption Roasters 71**

Salon 101 Spence Bakery & Café, The 77 Wild Tavern 105

MUSEUMS & GALLERIES

Barbican Centre 123, 125 British Museum 29 Burgh House & Hampstead Museum 83 Charles Dickens Museum 29 Dulwich Picture Gallery 87 Fashion and Textile Museum 42 Horniman Museum and Gardens 87 Kenwood House 67 London Glassblowing 43 Modern Art 126 Royal Drawing School, The 149 Temple Gallery, The 184 Wallace Collection, The 14 White Cube 39

PUBLIC SPACES & VENUES

2 Willow Road 79 3 Corners Adventure Playground 35 Abney Public Hall 75 Alexandra Palace 59, 60 Avondale Park 181 Barbican Centre 123, 125 Brockwell Lido 87 Brockwell Park 87 Bunhill Fields Burial Ground 125 Bussey Building, The 93 Camberwell College 93 Chiswick House 159 Chiswick Playhouse 162 Church of St Leonard 145 Clapham Common 109, 115

Clissold Park 77 Coram's Fields 31 Curzon Mayfair 20 Dulwich Library 91 Everyman Cinema 81 Fenton House 79 Fortune Street Park 123 Grand Union Canal 169 Gray's Inn Gardens 29 Hackney City Farm 132 Hampstead Community Centre 82 Hampstead Heath 63 Highgate Cemetery 64 Highgate Literary & Scientific Institution 66 Hogarth's House 159 Hyde Park 23 Hyde Park Stables 24 Ironmonger Row Baths 126 Keats House 79 Kenwood House 67 Kino Bermondsev 41 Lauderdale House 64 London Fields 135 London Fields Lido 135 London Symphony Orchestra St Luke's 123 London Wetland Centre 167 London Zoo 53 Olympic Cinema, The 167 Parkland Walk 60 Pond Square 63 Primrose Hill 53, 55 Puppet Theatre Barge 173 **Oueen's Park 153 Oueen's Wood 59** Regent's Canal 135, 169 Regent's Park 53

Roundhouse 57 Shoreditch Town Hall 145 Spa Fields 33 St John's Hyde Park 26 St Luke's & Christ Church 103 St Michael's Church 63 St Paul's Church 75 Stoke Newington Town Hall 77 Tyburn Convent 23 Victoria Park 139, 141 Wandsworth Common 109 Waterlow Park 64

SHOPS

Beauty Angela Flanders 129 Geo. F. Trumper 19 Lavingia Beauty Spa 116 Verde London 111

Bookshops

Daunt Books 13 Foster Books 161 House of Books, The 60 Paper & Cup 147 Primrose Hill Books 57 Queen's Park Books 153 Review 94

Fashion

69b Boutique 137 Aida 147 Annie's 71 Brimful Store, The 171 ChiChiRaRa 87 De Roemer 26

.....

Ediit 154 Folk 30 Jane Bourvis 178 Joseph 11 Maje 11 Philip Treacy 47

Food & Drink

Bottle Apostle 118, 139 Brew by Numbers 94 Cadenhead's Whisky Shop and Tasting Room 11 Chelsea Fishmonger 103 Cornercopia 99 Deli Downstairs 139 Fin & Flounder 135 Flock & Herd 93 Gather 95 Ginger Pig, The 139, 143 Hamish Johnston 111 Haynes, Hanson & Clark 103 lago Butchers 103 leroboams 45 Ionathan Norris 139 La Fromagerie 11, 14 Leila's Shop 149 MacFarlane's Deli 119 Melange Chocolate Shop & Café 96 Partridges 55 Paul Rothe & Son 14 Pavilion Bakery 137 People's Supermarket, The 30 Persepolis 93 Pie Man. The 103 Pistachio & Pickle 69 Salon 101 Salusbury Deli 155

Salusbury Winestore 155 Shepherd Foods 55

Homeware & Gifts Amaia Kids 106 Brimful Store. The 171 Choosing Keeping 129 Circus 101 Clifton Nurseries 172 Conran Shop, The 11 Cross, The 185 **Designers Guild 11** Felt 105 Forest 88 Grace and Thorn 132 Hampstead Antique and Craft Emporium 81 Haus 143 Labour and Wait 146 Les Couilles du Chien 178 London Glassblowing 43 LOOD 73 Mud Australia 24 Myriad 182 Nook 77 Old Cinema, The 162 Paint & Paper Library 107 Pentreath & Hall 30 Pierrepont Arcade 72 QT Toys 110 Roullier White 88 Search and Rescue 77 Stella Blunt 136 Strand Antiques 159 Summerill & Bishop 184 Tobias and the Angel 167 Toybox, The 142

Vintage Heaven 130 VV Rouleaux 11

Services & Specialists

East Central Cycles 37 Electric Daisy Flower Farm 66 Family Business, The 37 Forest 88 Grace and Thorn 132 Howarth 11 Lion Vibes 101 Lyon & Turnbull 26 Mungo & Maud 47 Robinson Pelham 107 Tomtom Cigars 48 VV Rouleaux 11

MARKETS

Barnes Farmers' Market 165 Bermondsey Square Antiques Market 41 Borough Market 39 Broadway Market 135, 136 Camden Passage Antique's Market 69, 72 Chiswick Car Boot 159 Columbia Road Flower Market 129 Exmouth Food Market 37 Golborne Road Market 175 Hampstead Antique and Craft Emporium 81 Hampstead Community Centre 82 Marylebone Farmers' Market 14 Netil Market 136 North Cross Road Market 87 Northcote Road Antiques Market 112 Northcote Road Market 109, 110 Pierrepont Arcade 72 Pimlico Road Farmers' Market 45

Portobello Road Market 175 Queen's Park Farmers' Market 157 Stoke Newington Farmers' Market 75 Whitecross Street Food Market 123 First published in 2013 by Frances Lincoln This edition first published in 2022 by Frances Lincoln, an imprint of The Quarto Group The Old Brewery, 6 Blundell Street, London N7 9BH, United Kingdom. www.Quarto.com

Copyright © 2013 Quarto Publishing plc. Text copyright © 2013 Zena Alkayat Illustrated maps © 2013 Jenny Seddon Photographs copyright © Kim Lightbody 2013 Except the following: p.12 top right Brian Anthony / Alamy Stock Photo; p.24 top Shutterstock.com / Willy Barton; p.25 © Mud Australia; p.61 bottom left © Polinate; p.66 right © Jorge Luis Diéguez; p.71 Pat Tuson / Alamy Stock Photo; p.76 bottom right Shutterstock.com / Charles Bowman; p.85 bottom left © Amaia; p.85 bottom right Shutterstock.com / Charles Bowman; p.85 bottom Village; p.106 © Amaia; p.107 left © Robinson Pelham; p.111 top © Orlando Gili; p.116 right © Lavingia Beauty Spa; p.117 © Emma Louise Pudge; p. 118 © Bottle Apostle; p.133 © Alexander Edwards; p.137 bottom Alena Kravchenko / Alamy Stock Photo; p.154 © The Toybox; p.149 top © Angela Moore; p.149 bottom Shutterstock.com / cktravels.com; p.154 right © Amber Rose Smith; p.155 bottom Yanice Idir / Alamy Stock Photo; p.184 left © Summerill & Bishop

Cover image: Antonio Olmos / Alamy Stock Photo

All rights reserved. No part of this publication may be reproduced or utilised in any form or by any means, electronic or mechanical, including photocopying, recording or by any information storage and retrieval system, without permission in writing from the publisher. Every effort has been made to trace the copyright holders of material quoted in this book. If application is made in writing to the publisher, any omissions will be include in future editions.

A catalogue record for this book is available from the British Library.

ISBN 978-0-7112-7622-2

Printed in China

Brimming with creative inspiration, how-to projects and useful information to enrich your everyday life, Quarto is a favourite destination for those pursuing their interests and passions. Visit our site and dig deeper with our books into your area of interest: Quarto Creates, Quarto Cooks, Quarto Homes, Quarto Lives, Quarto Drives, Quarto Explores, Quarto Gifts, or Quarto Kids.